Monet & Bazille

A Collaboration

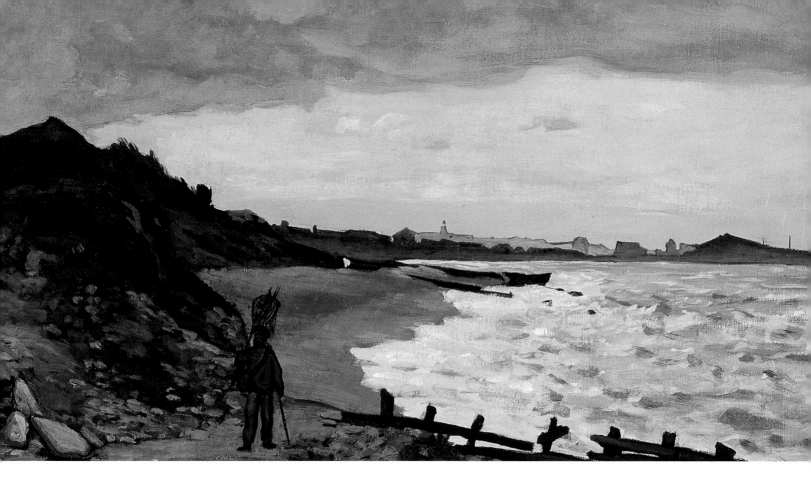

essays by
Kermit Swiler Champa and
Dianne W. Pitman
edited by
David A. Brenneman

High Museum of Art
in association with
Harry N. Abrams, Inc., Publishers

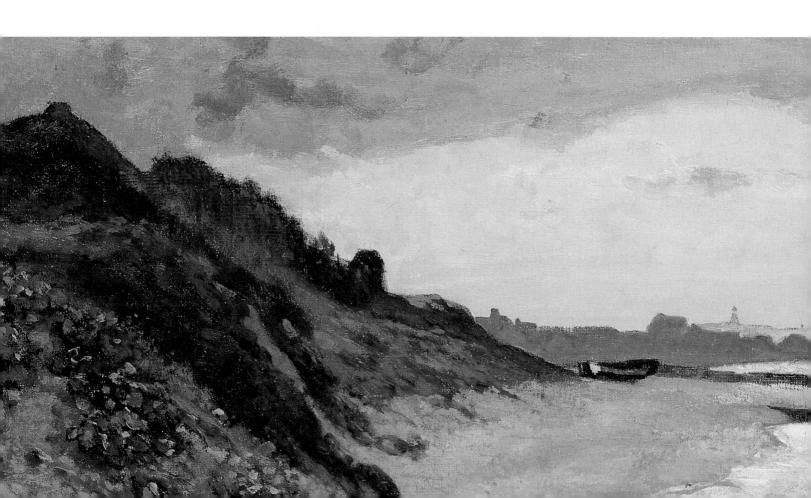

Monet
Bazille

A Collaboration

Monet & Bazille: A Collaboration
was on view at the High Museum of Art
Atlanta, Georgia
February 23–May 16, 1999

The exhibition was organized by the High Museum of Art.

Distributed in 1999 by Harry N. Abrams, Inc., New York

 Harry N. Abrams, Inc.
100 Fifth Avenue
New York, N.Y. 10011
www.abramsbooks.com

Library of Congress Cataloging-in-Publication Data
Champa, Kermit Swiler.
 Monet & Bazille : a collaboration / essays by Kermit
Swiler Champa and Dianne W. Pitman ; edited by David A.
Brenneman.
 p. cm.
 Catalog of an exhibition held at the High Museum of Art,
Atlanta, Ga., Feb. 27–May 16, 1999.
 Includes bibliographical references.
 ISBN 0-8109-6384-1 (hardcover : alk. paper)
 1. Monet, Claude, 1840–1926—Exhibitions. 2. Bazille,
Frédéric, 1841–1870—Exhibitions. 3. Artistic collabora-
tion—France—Exhibitions. I. Pitman, Dianne W., 1955– .
II. Brenneman, David A. III. High Museum of Art.
IV. Title. V. Title: Monet and Bazille.
 ND553.M7A4 1999
 759.4—dc21 98-31450

For the High Museum of Art
Kelly Morris, Manager of Publications
Anna Bloomfield, Associate Editor
Melissa Wargo, Assistant Editor

Produced by Marquand Books, Inc., Seattle
Designed by Susan E. Kelly
Proofread by Sherri Schultz and Marie Weiler

Printed by CS Graphics Pte., Ltd., Singapore

Pages 2–3: *(top)* Frédéric Bazille, *The Beach at Sainte-Adresse*
(detail), 1865, cat. 1; *(bottom)* Claude Monet, *Seaside at Sainte-
Adresse* (detail), 1864, cat. 2.

Page 18: Frédéric Bazille, *The Queen's Gate at Aigues-Mortes*
(detail), 1867, cat. 16.

Page 66: Claude Monet, *The Bodmer Oak, Fontainebleau Forest,
the Chailly Road* (detail), 1865, cat. 11.

Contents

Monet & Bazille: A Collaboration is organized by the High Museum of Art. The exhibition has been made possible by the James Starr Moore Memorial Exhibition Fund.

Generous support has also been provided by Equity Office, the Exposition Foundation, Inc., The Forward Arts Foundation, Inc. of Atlanta, Livingston Foundation, and the National Endowment for the Arts.

Acknowledgments

This exhibition could not have taken place without the generous financial support of many individuals and organizations. Mrs. Sara Moore, through the James Starr Moore Memorial Exhibition Fund, was instrumental as a former president of The Forward Arts Foundation in the High's acquisition of Frédéric Bazille's *Beach at Sainte-Adresse,* which serves as the heart of the exhibition. The painting was given to the Museum in honor of Frances Floyd Cocke by The Forward Arts Foundation of Atlanta. We owe sincere gratitude both to Mrs. Cocke's daughter, Jane Black, for her gift through the Exposition Foundation, and to The Forward Arts Foundation, through the leadership of Betty Edge. Additional funding has been provided by Equity Office. Since its first involvement with the High during the Paradise Project in 1995, Equity Office has supported some of our most important activities. We are grateful for their commitment and appreciate the example they have set for corporate philanthropy in Atlanta. We thank the Livingston Foundation for continuing a long history of Museum support through a gift to this exhibition and its educational programs. Under the leadership of Jonathan Golden and his fellow Trustees, the Livingston Foundation continues to support the High's efforts to offer quality cultural programs like this one. We are also grateful for a grant from the National Endowment for the Arts, under the category of Creation and Presentation. This grant is particularly meaningful in light of dramatically increased competition for agency funds due to national budget cuts.

In undertaking the planning of this exhibition, my largest debt of gratitude is to Michael Shapiro and Ned Rifkin for their advice and for their ongoing support of my work. I am also grateful to Kermit Swiler Champa and Dianne W. Pitman, who generously acted as unofficial advisors. I would like to thank Charles Stuckey, Senior Curator of the Kimbell Art Museum, Fort Worth, Texas, who was very encouraging when I embarked on this project almost two years ago. In addition, I would like to thank Joachim Pissarro, Seymour H. Knox Jr. Curator of European and Contemporary Art of the Yale University Art Gallery, and former Senior Curator of the Kimbell Art Museum; Oliver Barker of Sotheby's, London; Polly Sartori of Christie's, New York; Alexandra Murphy; and John Leighton, Director of the Van Gogh Museum and former Curator of Nineteenth-Century Paintings at the National Gallery, London, for supporting key loans to the exhibition.

For their assistance with this exhibition, I would like to acknowledge James N. Wood, President and Director, Douglas Druick, Searle Curator of European Painting and Prince Trust Curator of Prints and Drawings, and Gloria Groom, Associate Curator of European Painting, The Art Institute of Chicago; William J. Hennessey, Director, and Jefferson Harrison, Chief Curator, The Chrysler Museum of Art, Norfolk, Virginia; Michel Hilaire, Directeur et Conservateur du Patrimoine, Musée Fabre, Montpellier, France; Richard B. Kellam, Virginia Beach, Virginia; Edmund P. Pillsbury, Director, and Charles Stuckey, Senior Curator, Kimbell Art Museum; Mr. and Mrs. Nathan I. Lipson, Atlanta; Graham W. J. Beal, Director, and J. Patrice Marandel, Curator of European Painting and Sculpture, Los Angeles County Museum of Art; Arnaud d'Hauterives, Directeur, and Marianne Delafond,

Conservateur, Musée Marmottan, Paris; Philippe de Montebello, Director, and Gary Tinterow, Engelhard Curator of European Paintings, The Metropolitan Museum of Art, New York; Evan M. Maurer, Director and CEO, and Patrick Noon, Patrick and Aimée Butler Curator of Paintings, The Minneapolis Institute of Arts; Earl A. Powell III, Director, and Philip Conisbee, Curator of French Paintings, National Gallery of Art, Washington, D.C.; Neil MacGregor, Director, Christopher Brown, Chief Curator, and Christopher Riopelle, Curator of Nineteenth Century Paintings, National Gallery, London; Susannah Fabing, Director, and Linda Muehlig, Associate Curator of Painting and Sculpture, Smith College Museum of Art, Northampton, Massachusetts; Katharine C. Lee, Director, and Malcolm Cormack, Paul Mellon Curator, Virginia Museum of Fine Arts, Richmond; Joseph Baillio and Ay-Whang Hsia, Vice Presidents, Wildenstein and Co., Inc., New York; and Michel Schulman, Paris.

From the High's staff, I would like to commend Anna Bloomfield and Kelly Morris, who did a first-rate job editing the texts for the catalogue. I would also like to thank Susan Brown, Holly Caswell, and Keira Ellis of the development department for their hard work in securing funding for the exhibition. Frances Francis and Jody Cohen of the registration department dealt efficiently with loans. I would like to acknowledge Audrey Nassieu-Maupas and Elisabeth Chauvin for their assistance with research for the exhibition. Finally, I would like to thank Phaedra Siebert, assistant in the High's department of European art, for her unfailing help at every stage in the planning and execution of this project.

David A. Brenneman
Frances B. Bunzl Family Curator of European Art
High Museum of Art

Preface

One of the fundamental methods of gleaning insights about art is what art historians call "compare and contrast." The underlying notion is that we can learn more about one object if we see it in relationship to another one that is somehow related. This exhibition grew out of a need for the High Museum of Art to understand more fully the contents of its own collections. In 1980, just over one hundred years after the picture had been painted, the High purchased *The Beach at Sainte-Adresse* by Frédéric Bazille with a grant from our first supporters and friends, The Forward Arts Foundation. Appropriately, this acquisition was dedicated to one of their founding members, and a great collector and patron of the High, Frances Floyd Cocke. The partnership between patron and institution, between individual collector and talented scholar, is what makes the dynamic of working in art museums so exciting and gratifying.

Dr. David A. Brenneman, the High's Frances B. Bunzl Family Curator of European Art, is the reason this exhibition and its accompanying catalogue have come to life. His study of this important painting in our collection, one often requested by other museums for loan, opened up a consideration of it in relation to another, done by Claude Monet, in the collection of the Minneapolis Institute of Arts. What we learned by seeing them in tandem inspired the consideration of the working relationship, the collaboration, of two young French artists.

Before the term Impressionism was coined (prompted by a pejorative review by a contemporary critic who looked askance at the "unfinished" paintings as "merely impressions"), before people lined up at the Art Institute of Chicago to be treated to a retrospective of arguably the most revered artists of the nineteenth century, or came in droves to the Metropolitan Museum of Art in New York to witness a rare compilation of great works by these French masters, there were a couple of young, bold, and talented artists named Claude Monet and Frédéric Bazille. They were friends who worked side by side at times, who shared meals and studio space. They, along with Pierre-Auguste Renoir, forged a new language of rendering the natural world, but did so against the grain of convention and acceptable style.

It is always important to review what is already known. Sometimes the critical facts slip into a quasi-fiction, like stories that are retold over generations. It is useful and significant to understand the nature of artists creating, to understand that they do not generate their work in a vacuum. In the next century, one must ask what the twentieth century would have looked like if Picasso had not worked closely with Georges Braque from 1909 to 1912. The early collaboration between Monet and Bazille is just as important to the evolution of Impressionism as that of Picasso and Braque is to the evolution of Cubism. I sincerely hope that this "compare/contrast" study will be as useful and enjoyable to our visitors as it has been to our own appreciation of the painting in the High's permanent collection.

Ned Rifkin
Nancy and Holcombe T. Green, Jr. Director
High Museum of Art

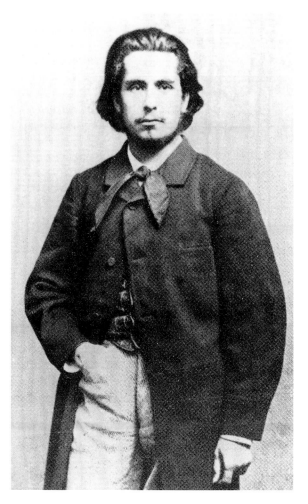

Fig. 1. Étienne Carjat
Claude Monet, ca. 1860–61
Photograph
Private Collection

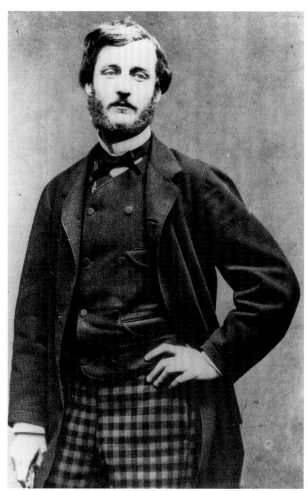

Fig. 2. Étienne Carjat
Frédéric Bazille, 1864
Photograph
Private Collection

Introduction

From 1863, when Claude Monet and Frédéric Bazille first met as students, to 1870, when war broke out between France and Prussia and cut short Bazille's life, these two artists struggled together, and to a certain extent against each other, to forge their artistic identities. During their seven-year friendship, they shared a succession of Paris studios, which functioned variously as showrooms for their paintings, meeting places for sympathetic colleagues, and laboratories for their explorations of painting. In those Paris studios, they used the contemporary work of Gustave Courbet, Edouard Manet, and other Barbizon and Realist artists as a point of departure and engaged in an intricate exchange with the ultimate goal of gaining public recognition for themselves and their work. Bazille's tragic early death prevented him from seeing the flowering in the 1870s of Impressionism, the foundations of which he had helped to build with Monet.

Given the widely acknowledged importance of their relationship, it is somewhat surprising that there have been no exhibitions or publications devoted specifically to Monet and Bazille's collaboration. Both Monet and Bazille scholars have largely discussed the relationship only insofar as it concerns their studies of the individual artists, but an intensive comparative study of Monet's and Bazille's achievements has never been undertaken. The present exhibition and its accompanying catalogue seek to rectify that situation.

In addition to the need for a focused evaluation of Monet and Bazille's relationship, a more specific motivation for this exhibition was a desire to clarify the issues surrounding the production of one of the High Museum of Art's most important and best-known European paintings, Bazille's *Beach at Sainte-Adresse,* painted in 1865 (cat. 1).[1] The origin of the High's painting is clouded by the fact that its composition closely resembles that of a painting by Monet in the collection of the Minneapolis Institute of Arts (cat. 2). Both works resulted from a trip the artists took to the Normandy coast in 1864, and the paintings show nearly identical views of the beach of Sainte-Adresse with the skyline of the city of Le Havre in the distance. How did Monet and Bazille produce such similar pictures? Did they paint the same view while standing shoulder to shoulder, or did one artist copy the work of the other? Perhaps more importantly, what do these pictures have to say about the nature of their relationship?

These questions have not been answered conclusively, even though art historians have reached a certain consensus regarding the two works. The first scholar to take an interest in the comparison of Bazille's and Monet's views of the beach

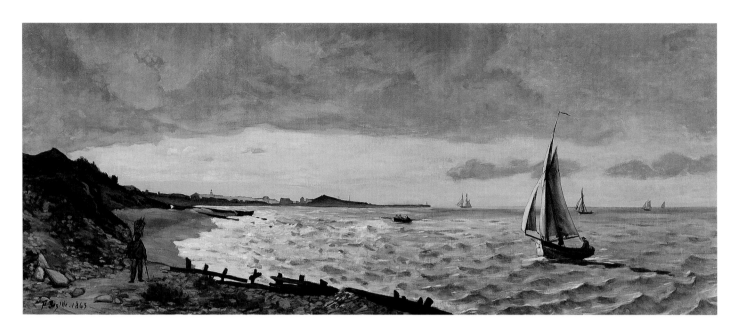

1. Frédéric Bazille

The Beach at Sainte-Adresse, 1865

Oil on canvas, 23 × 55⅛ inches (58.4 × 140 cm)
High Museum of Art; Gift of The Forward Arts
Foundation in honor of Frances Floyd Cocke

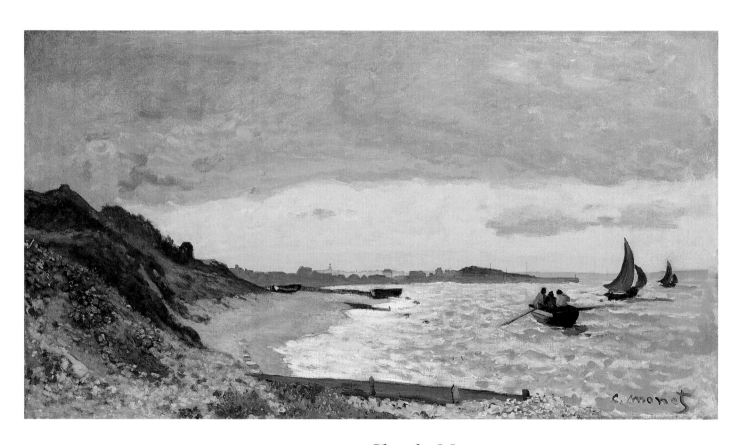

2. Claude Monet

Seaside at Sainte-Adresse, 1864

Oil on canvas, 15¾ × 28¾ inches (40 × 73 cm)
The Minneapolis Institute of Arts; Gift of Mr. and
Mrs. Theodore Bennett

at Sainte-Adresse and to publish adjacent photographs of them was the great historian of Impressionism John Rewald. He included the comparison in the revised and expanded edition of his *History of Impressionism* (1961), where it enhanced his deft telling of Impressionism's story.[2] Rewald included the comparison of the two paintings in his book presumably in order to illustrate the indebtedness of the youthful Monet and Bazille to the landscape painting traditions established at Barbizon and the Normandy coast in the preceding decades. Although Rewald was the first to publish the comparison and to feature it as an important moment in the early history of Impressionism, he unfortunately did not comment on its meaning within the body of his text. Rewald's identification of the works was also flawed: he mistakenly gave the location of the Bazille as the seashore near Honfleur and dated the painting by Monet to 1865. Rewald left fundamental questions about the works unanswered.

Joel Isaacson was the first to attempt to answer in print a number of basic questions about the relationship of the High's Bazille to the Minneapolis Monet.[3] When was Monet's undated painting completed? Was Bazille's painting, which is dated 1865, begun on the spot in 1864 and then finished in the studio a year later? Finally, did Bazille merely copy Monet's painting, or does it represent a more original effort on Bazille's part? For answers to these questions, Isaacson turned to Bazille's correspondence to his parents from the spring and summer of 1865, in which Bazille mentioned the fact that his uncle had commissioned two overdoor paintings from him and that he was having difficulty achieving the effects he wanted.[4] From the correspondence, Isaacson deduced that Monet probably painted his work at Sainte-Adresse in 1864, and that "Bazille's painting was executed only in 1865 to fulfill the above-mentioned commission."[5] Given that the Monet was painted first, Isaacson also concluded that Bazille's painting was essentially a tentative copy of Monet's. In Isaacson's words, "Bazille's lack of certitude in coping with the project is pointed up by his dependence upon [Monet's] composition."[6]

Fig. 3. Claude Monet
Seaside at Sainte-Adresse, 1864
(before cleaning)

The most recent published discussion of the comparison, which appears in Michel Schulman's catalogue raisonné of Bazille, is in general agreement with previous scholars that the Bazille closely reproduces the Monet.[7] However, Schulman was careful to stress important differences between the two works, presumably in order to play up Bazille's originality. First, he pointed out the more expansive format of the Bazille, which allowed for the inclusion of a larger boat and a figure on the beach.[8] Second, Schulman noted the differing tonalities of the two pictures. Here he recalled Gaston Poulain's observations on the "cold tone" and "meticulous writing" of Bazille's picture, in contrast to the relative warmth and painterly impasto of the Monet. A juxtaposition of color images of the two works reinforces this point.

In addition to the scholarly discussions, there have been at least two opportunities to see the Monet and the Bazille together. The first occurred in 1978,

when J. Patrice Marandel included them in his exhibition *Frédéric Bazille and Early Impressionism,* which was held at the Art Institute of Chicago.[9] That exhibition represented the first major showing of Bazille's work in the United States, and it provided an opportunity for scholars to inspect the two works firsthand. Although Marandel's conclusions generally echoed Isaacson's, he also suggested that perhaps Bazille's painting was begun on the spot in Sainte-Adresse in 1864 but completed in the studio in Paris in 1865. Marandel's theory was not taken up by most scholars, probably because the Bazille is painted on such a large canvas that it seems unlikely that he would have lugged it along on a painting expedition.

The two paintings were recently seen together again at the Musée d'Orsay and the Metropolitan Museum of Art's joint exhibition *The Origins of Impressionism,* in 1994–95. Gary Tinterow, the author of the catalogue entries for both the Monet and the Bazille, reiterated the view that Bazille's painting was a relatively straightforward copy of the Monet, which was probably available for Bazille to use in the Paris studio that the artists shared.[10] Tinterow, like Isaacson, made extensive use of Bazille's letters, and he pointed out that in one of them, Bazille mentioned that he had begun two canvases, which he then completely reworked. Bazille's father had taken this to mean that his son had begun two entirely new canvases, but Tinterow speculated that the new compositions were simply painted over the old ones. Tinterow indicated that an x-radiograph of Bazille's seascape might reveal an abandoned composition.

After thirty-five years of scholarly commentary and multiple opportunities to see Monet's and Bazille's views of the beach at Sainte-Adresse together, what new information could be brought to bear on the interpretation of their relationship? As Tinterow's remarks suggested, neither painting had undergone extensive technical analysis since they were acquired. In preparation for this exhibition, therefore, the two paintings were sent to the laboratory of the Upper Midwest Conservation Association for examination. Prior to the arrival of the High's Bazille in November 1996, David Marquis, the paintings conservator at the laboratory, had already begun to clean the Monet, and it soon became clear that it was covered with a substantial amount of discolored varnish and overpaint (fig. 3).[11] The removal of this varnish and paint revealed a picture that is much closer in color and tone to the Bazille than was previously thought. When they were placed side by side in the laboratory, the similarity was striking. Whereas published comparisons showed the Monet to have a golden tonality, the cleaning revealed that both works exhibit the same drab colors of an overcast day on the Normandy beaches. The cleaning of the Monet showed that both artists used not only an almost identical range of colors, but also almost identical brushwork in the construction of certain features of the seascape, such as the beach. X-radiographs of both pictures further revealed that there was virtually no reworking of Monet's composition, while there was evidence that Bazille had substantially revised an earlier composition. Unfortunately, it is impossible at this time to come to any definitive conclusions about the earlier composition by Bazille based only on the evidence of the x-radiograph.

This new information would seem to confirm the view that Bazille essentially copied his painting directly from Monet's. Why would Bazille have done this? Probably because Monet was pressuring him to finish his uncle's commission so that he could hurry to Chailly, near the Forest of Fontainebleau, where

Monet needed him to pose for a major painting he was undertaking.[12] The laboratory results corroborate Bazille's statements in his letters to his parents that he had aborted an earlier composition. In light of the documentary evidence of Monet's demanding letters and Bazille's admitted difficulties in devising a satisfactory composition, it seems entirely plausible that Bazille simply turned to the work of his friend and colleague to relieve himself of what must have been a burdensome task.

If Bazille relied so heavily on the work of his friend, what does this say about the character of their connection? It would seem to support the view that Bazille was, at least initially, a "talented amateur" who modeled his efforts on those of a superior artist. As Kermit Champa argued in 1973, Bazille's copy of Monet's painting indicated "the level of quality his [Bazille's] painting could achieve under the direct influence of a more formidable talent."[13] But this assessment is not all that remains to be said of the two works and consequently of the working relationship of the two artists.

Even though laboratory analysis highlighted the remarkable similarity of the two pictures, it also underscored major differences between them. The most important of these were the artists' respective working methods. Examination under the microscope revealed that Monet applied all his paint layers simultaneously, or at least within a relatively short time.[14] This was deduced from the fact that the lower and upper paint layers show evidence of blending. Microscopic examination of the Bazille revealed, on the other hand, that the lower paint layers had time to dry before the figures and sailboats were applied, and that these specific areas show no blending. These observations came as no surprise, since later works by both artists exhibit similar working methods.[15] Their dissimilar methods resulted in very different pictorial effects: in the case of Bazille, a sometimes disconcerting, cut-out quality of the figures, and in Monet's case, the seamless integration of figure and landscape.

There are also lingering questions regarding the significant variation in the scale and positioning of the human figures within the landscapes of these two works. Bazille included a figure walking on the beach and a large sailboat, which are not present in the Monet. Additionally, the orientation of the figures in relation to the beholder is different in each picture: in the Bazille they move outward from the picture, but in the Monet they move into the distance of the fictive space of the seascape.

Questions raised by the artists' differences of technique, scale, and positioning of figures complicate the seemingly clear-cut view that Monet and Bazille were engaged in a lopsided alliance. For example, if they studied in the same studio and worked so closely together, why did they adopt such different methods? Furthermore, why did Bazille make such relatively significant alterations to Monet's composition when he apparently did not have to? In the following essays, Dianne Pitman and Kermit Champa, two scholars who have written elsewhere about Monet and Bazille, elaborate their views on the character of the artists' relationship and on their contrasting, and sometimes conflicting, approaches to painting.[16] As the essays that follow will demonstrate, the distinctive qualities of Monet's and Bazille's approaches, which were incipient in the two seemingly identical views of the beach at Sainte-Adresse, continued to surface and to differentiate the two artists in the other works they produced during their brief association. Despite the fact that Bazille was happy to "borrow" the

work of his friend in 1865, his painting, particularly from 1868 to 1870, developed in an original direction and seems to have addressed differently the issues that interested Monet. Precisely how did they diverge? How were they similar? More importantly, was Bazille ever able to achieve an artistic identity independent of his association with Monet? Although it is beyond the scope of this modest exhibition and its accompanying catalogue to provide definitive answers to the multitude of questions surrounding Monet and Bazille's seven-year association, it is our hope that the careful consideration of the visual evidence of their achievements during the 1860s will ultimately lead to a thought-provoking re-evaluation of their complex collaboration.

David A. Brenneman

Notes

1. The High's Bazille has been included in three major loan exhibitions within the past ten years: *Corot to Monet: The Rise of Landscape Painting in France* (organized by the Currier Gallery of Art, 1991–92); *Frédéric Bazille: Prophet of Impressionism* (organized by the Musée Fabre, Montpellier, France, and the Brooklyn Museum of Art, 1992–93); and *The Origins of Impressionism* (organized by the Musée d'Orsay and the Metropolitan Museum of Art, 1994–95).

2. John Rewald, *The History of Impressionism*, rev. ed. (New York: Museum of Modern Art, 1961), p. 110. The comparison was not included in the original 1946 edition, presumably because the works came into public view only in the early 1950s. Despite the fact that there were references to Bazille's seascape in Gaston Poulain's classic biography of the artist (*Bazille et ses amis* [Paris: Renaissance du Livre, 1932], pp. 52 and 211) and that it had been included in a major Bazille retrospective organized by the Wildenstein Gallery in Paris in 1950 (cat. no. 15), a photograph of the High's *Beach at Sainte-Adresse* by Bazille was first reproduced and widely distributed in François Daulte's 1952 biography and catalogue raisonné of the artist. See *Frédéric Bazille et son temps* (Geneva: Pierre Cailler), p. 172, cat. no. 15.1 (reproduced at the back of the catalogue). The painting by Monet appears not to have been widely known until it entered the collection of the Minneapolis Institute of Arts in 1953. It was reproduced in the catalogue of the exhibition from which it was purchased. See *French Masters of the XIX and XX Centuries* (London:

Marlborough Fine Arts, Ltd., 1952), no. 25. The Minneapolis Institute of Arts also published it the year after its acquisition. See S. L. Catlin, "Institute Receives Gift of Early Landscape by Claude Monet," *The Minneapolis Institute of Arts Bulletin* 43 (6 February 1954): 10–14.

3. Joel Isaacson, *Monet: Le déjeuner sur l'herbe* (London: Penguin Press, 1972), pp. 98–99 n. 13.

4. The unusual horizontal format of Bazille's seascape and its pendant, a view of his uncle's farm at Saint-Sauveur, suggests that they are the overdoors mentioned in Bazille's letters. The relevant passages from Bazille's letters to his parents are cited in Gary Tinterow's entry in the catalogue *Origins of Impressionism* (New York: Metropolitan Museum of Art, 1994), p. 329.

5. Isaacson, *Monet*, p. 99.

6. Ibid.

7. Michel Schulman, *Frédéric Bazille, 1841–1870: Catalogue raisonné* (Paris: Éditions de l'Amateur, 1995), pp. 130–31, cat. no. 18.

8. The differences in scale and position of figures and boats in the paintings by Monet and Bazille are discussed at some length in Dianne W. Pitman's entry on the High's Bazille in Aleth Jourdan et al., *Frédéric Bazille: Prophet of Impressionism* (Brooklyn: Brooklyn Museum of Art; Montpellier: Musée Fabre, 1992), p. 89. Dr. Pitman elaborates on her views regarding the significance of the compositional differences between the two works in her essay for this catalogue.

9. J. Patrice Marandel, ed., *Frédéric Bazille and Early Impressionism* (Chicago: Art Institute of Chicago, 1978), pp. 54–55 and 134–35, cat. nos. 17, 69.

10. Gary Tinterow and Henri Loyrette, *Origins of Impressionism,* p. 329.

11. I would like to thank Dr. Charles Stuckey, the former curator of paintings at the Minneapolis Institute of Arts, who initiated the technical analysis and conservation of Monet's *Seaside at Sainte-Adresse.*

12. See Schulman, *Bazille,* "Correspondance," especially pp. 344 and 346, letter nos. 107, 108, and 116.

13. Kermit Swiler Champa, *Studies in Early Impressionism* (New Haven: Yale University Press, 1973), p. 85.

14. This examination was undertaken by Kennis Kirby, former associate paintings conservator of the Southeastern Regional Conservation Center at the High Museum of Art, in November 1996.

15. In their discussion of the technique employed by Monet in his *Bathers at La Grenouillère* of 1869, the curatorial and conservation staff of the National Gallery, London, noted, "The immediacy of painting wet-into-wet, and drawing one colour into another, is clearly seen throughout the composition, perhaps most obviously in the painting of the water and the boats, while even the purer-coloured strokes and touches of unmixed paint at the surface were dabbed and drawn over the underpainting before it was dry." David Bomford, Jo Kirby, John Leighton, and Ashok Roy, *Art in the Making: Impressionism* (New Haven: Yale University Press; London: National Gallery, 1990), p. 124. Bazille's technique of painting his figures only after the paint of the landscape had dried is easily seen in an unfinished work of 1867, *The Rose Laurels* (Cincinnati Art Museum). In that painting, the garden background is finished, and over it an unfinished figure of a woman seated on a bench in the lower right foreground has been sketched in.

16. Champa, *Studies,* pp. 83–90; "Frédéric Bazille, the 1978 Retrospective Exhibition," *Arts Magazine* 52 (June 1978): 108–10; Dianne W. Pitman, "Bazille and the Art Criticism of His Time," in *Frédéric Bazille: Prophet of Impressionism,* pp. 51–59; and *Bazille: Purity, Pose, and Painting in the 1860s* (University Park: Pennsylvania State University Press, 1998).

Overlapping Frames

Dianne W. Pitman

During the early years of their friendship, Monet and Bazille painted side by side and posed for one another in the open air of the French countryside and in the studios they shared in Paris. They assisted each other with such practical matters as storing and shipping canvases, providing frames, seeking patrons, and making arrangements for exhibitions. And through the medium of their paintings, they engaged in a dialogue of quotation, modification, and opposition. Given the imperative for artists to establish distinct individual identities, and given their particular personalities and ambitions, their informal collaboration posed as many problems as it solved. Most accounts of their relationship have stressed the friendly rivalry between them and the increasingly apparent differences between their preferred subjects and techniques. I would like to emphasize instead what Bazille and Monet shared: if not quite a joint practice, then an overlapping set of practices deeply involved with issues of framing.

Frames not only embellish paintings, they also signify completion and conceptual integrity. "A painting gains one hundred per cent in a good frame," wrote Monet to Bazille in October 1864.[1] Coming from an ambitious young painter, that is a remarkable statement; all the more so in the context in which it was written. Monet was preparing to ship some of his paintings for Bazille, who was staying with his parents in Montpellier, to show to collectors there. In the event, Monet ended up framing and sending not the reworked versions he had hoped to complete but his original oil sketches from nature, which he himself termed "studies."[2] The typical gilt or black-stained frame of the 1860s, which acted as a strict visual barrier between a picture and the world around it, would have conferred upon those studies a certain conceptual self-sufficiency. Still in the future were the simple white frames favored by some of the Impressionists and the colored and patterned frames of Neo- and Post-Impressionism, designed to mediate more subtly between painting and exterior world. And more extreme measures such as the twentieth-century trick of not framing finished paintings at all—which compels the beholder to wonder when they stop being pictures and become objects of another sort—would have made little sense in the mid-nineteenth-century context.[3]

Manipulating the physical, three-dimensional, added-on frame, however, raises only the most obvious questions about the relationship of the picture to what surrounds it. Painters have other means for addressing that concern. Forms can be organized within a composition to emphasize—or de-emphasize—the edges of the canvas, suggesting varying levels of continuity with the outside world.

The degree of finish and the presence of a signature can at once establish a painting's separateness and remind us of the labor of the artist who made it. Depicting the painter at work or the tools of painting, and copying or obviously quoting from other works of art, can add a note of self-reflexivity and put pressure on the idea that a painting records "pure" or unmediated visual experience. Objects can be arranged and people can be posed so as to heighten our awareness of the painter's presence before the canvas, which then seems less a window into a separate world than an extension of our own. Monet and Bazille made use of all of these strategies in the early years of their friendship, while they also sought to find or create the appropriate audience for their art. Their extensive experiments with frame, finish, and self-reference can be understood as part of the larger project, which they shared with others of their generation, of establishing a new kind of painting involving a new relationship between picture and beholder.[4]

In this essay I invite you to step into a series of images, in your imagination, and share the painters' experiences of their subjects, or stand back from them and reflect upon the contexts in which they were made. My intention is to mimic, to a certain extent, the diverse strategies of framing that are our subject. Of course, the medium of art historical narrative provides its own type of contextual frame for pictures, while exhibitions reframe them both literally and figuratively. Although Bazille and Monet could not have foreseen the formats of today's exhibitions or the extent of our interest in their lives and works, they were acutely aware of the beholder's role and the importance of the viewing context. Their paintings compel us to reflect upon how we, too, actively frame and reframe the objects of our interest.

Sainte-Adresse

A solid mass of cloud hangs overhead, its underside touched with yellow light and shaded to lavender; but farther down the coast it has lifted, and just a few fragments of wet gray cloud float there against a light golden sky. The water, ruffled by changing winds, reflects the yellow-gold color of the sky over an undertone of bluish green. Dark bluffs slope abruptly down to the beach, which curves away from a strip of rocky ground in the foreground toward a spit of land defining the other side of the bay in the distance. Wooden fence-like barriers run down to the water at intervals along the beach, sheltering any fishing boats that have been pulled ashore and helping to slow the eternal drifting of the sand. On the horizon, pale in the haze, looms the skyline of a distant city.

And all of this is created, or recreated, on a canvas by the varying touch of a painter's brush and the subtle modulations of his rather restrained palette (fig. 4, cat. 2). Imagine stepping back from the canvas in progress and focusing instead on the real land and sea and air: consider to what extent the painting reproduces the world and to what extent it crystallizes and transforms it. The clouds drift, the waves roll, the shrubs and the sand stir in the wind, and the quality of light changes constantly. The painting at once mimics these effects and freezes them, pulling them out of the flux and containing them within four strict edges.[5]

The beach in question is at Sainte-Adresse on the coast of Normandy, in the summer of 1864. The painter, Claude Monet, has returned after a winter

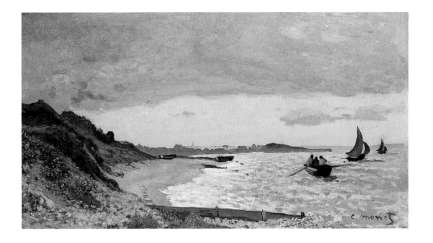

Fig. 4. Claude Monet
Seaside at Sainte-Adresse, 1864
Oil on canvas, 15¾ ×
28¾ inches (40 × 73 cm)
The Minneapolis Institute of
Arts; Gift of Mr. and Mrs.
Theodore Bennett
(see page 12)

in Paris to the region where he grew up and learned to paint, bringing with him his friend Frédéric Bazille. The two young men have been working on the other side of the Seine estuary at Honfleur (cat. 3), lodging and taking their meals at the farm of Saint-Siméon, a rustic and inexpensive retreat popular with artists. Now they have come to Sainte-Adresse to stay with Monet's family and search for new motifs to paint.

At the end of the painting session, or perhaps a few hours later, in a corner of the family home appropriated as a temporary studio, we might catch Monet touching up his view of the beach at Sainte-Adresse. Now we are less aware of the magic of reproduction and more conscious of the artist's craft and labor. Working from memory or from his own pencil sketches, he adds to his picture a rowboat with three passengers heading away from us, toward the center of the canvas and the distant city. (Something seems odd about the boat's scale or placement, but then it is so hard to measure the sea!) Farther out, he paints two sailboats standing out from the shore, the shape of the smaller one echoing that of the larger, both of them countering the movement of the rowboat and nicely defining the edge of the previously rather empty canvas. The boats also dramatize depth, of course, with their implied direction and their differences of scale, and they add human interest and a suggestion of narrative. Here and there across the surface, Monet touches up the textures and colors, and finally he places his signature at lower right, closing in the composition even more securely. These finishing touches transform the seascape from what traditionally might have been considered a mere sketch, a study from nature executed in the open air, into something more like a completed painting.[6] If he can afford to furnish the mandatory frame, Monet can hope to sell it—perhaps to one of the collectors in Montpellier that Bazille will approach on his behalf.

A compulsive worker and great lover of nature, Monet returns repeatedly to the shore. On another day on the beach at Sainte-Adresse, he faces north, toward the spot where the headland of the Hève River drops sharply down to the sea and the edge of the bay curves back out to meet it (cat. 4). This time he uses nearly the same color for both overcast sky and somber water, and he gives them almost the same texture: irregular but smoothed off, edged with thicker, drier strokes of white to denote the gathering clouds on the horizon and the foam pushed up on the beach by the high tide. He forms the cliffs and beach, in contrast, out of small, discrete patches of thicker paint, so schematized in the foreground that they almost negate any sense of recession and call attention instead to the materiality of paint on canvas. At some point, Monet will add virtually the

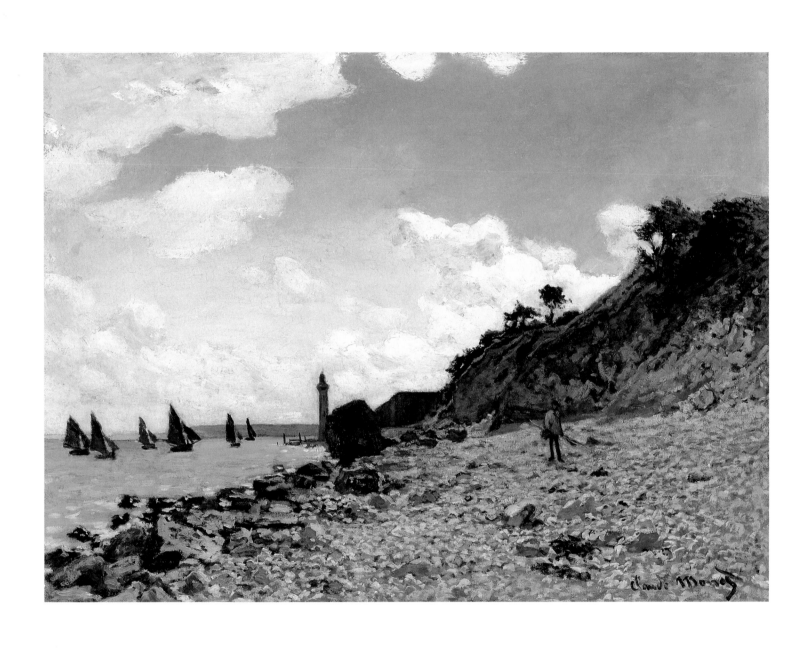

3. Claude Monet

Beach at Honfleur, 1864–65

Oil on canvas, 23½ × 32 inches (59.7 × 81.3 cm)
Los Angeles County Museum of Art;
Gift of Mrs. Reese Hale Taylor

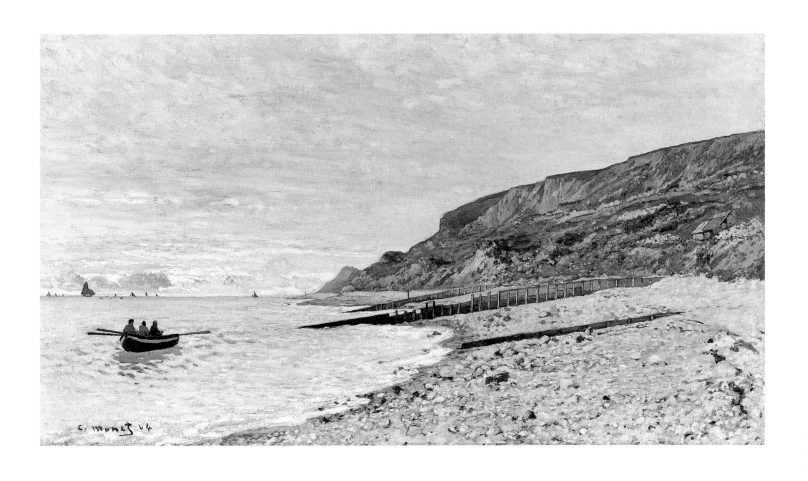

4. Claude Monet

The Headland of the Hève, Sainte-Adresse, 1864

Oil on canvas, 16⅛ × 28¾ inches (41 × 73 cm)
National Gallery, London

Fig. 5. Claude Monet
*Horses at the Headland
of the Hève,* 1864
Oil on canvas, 20¼ ×
29 inches (51.4 × 73.7 cm)
Private Collection

same finishing touches as before: a rowboat strategically placed in the open water, tiny sailboats in the distance to establish depth, and a signature that fills in the otherwise flattest and emptiest corner of the composition.

And again: on another canvas of a different shape, the same view but at low tide, with the sea pulling back from the rocks and exposing a band of fine, wet sand that reflects the sky (fig. 5). Although the clouds have grown more massive and solid than before, patches of blue sky and brighter cloud call for even greater variation of textures in the painted surface. The taller format of this second view of the headland of the Hève contains less horizontal spread of sea and landscape, emphasizing instead the dramatic sky and the beach in the foreground, where horses, men, and wagons move away from us along the smoother terrain uncovered by the low tide. High tide and low tide: other artists have painted pairs of pictures with these themes before, and other pairs that illustrate natural cycles such as day and night or winter and summer. But given the different formats of his two pictures, Monet seems less interested in any overt symbolism or strategy for exhibition than in his own experience of continuity and change.

The following winter, Monet repeats the scene again, though in a different manner (cat. 5). On a canvas of nearly double the dimensions and four times the surface area, he recreates and readjusts the picture of the beach at low tide, working not from nature in the open air but from his own earlier study in the neutral space of the studio in Paris that he shares with Bazille. He clarifies the color harmonies—silvery gray in sky and foreground modulating to yellow-green and blue-green in the water, moss green and ochre on the cliffs—and he repeats the pattern of flat color patches and abbreviated brushstrokes that are at once so illusionistic and so demonstrative of the medium. Smoother blended areas and longer, more linear brushstrokes appear too, particularly in the wet sand in the foreground that reflects the men and horses and the sinuous pattern of foam and wagon tracks that winds into the distance. Monet adds another wooden barrier in the right foreground to establish more depth, and he reduces the numbers of the human figures, horses, and wagons and moves them farther back in the picture, causing all their movements to converge toward the bright horizon at the center. In accordance with the rhythm of shapes in the foreground, he inserts a sailboat on the horizon at left, and this too appears to move toward the central zone of convergence. Standing out against the flat, smooth surface of sand at lower right and reaffirming that corner of the canvas are the artist's signature and the date: "Claude Monet 1865."

Just a few weeks after his finishing touches were applied, thousands of viewers gaze upon Monet's large painting at the annual government-sponsored Salon in Paris. Its stronger value structure, its more varied treatment of textures, its more traditional depth and recession, its larger format, and last but not least the conventional gold frame that defines and encloses it as a separate, concentrated space—all of these features that distinguish *The Headland of the Hève at Low Tide* from Monet's earlier versions also help it hold its own on the crowded walls of the Salon. Has Monet suppressed his own style in order to make the

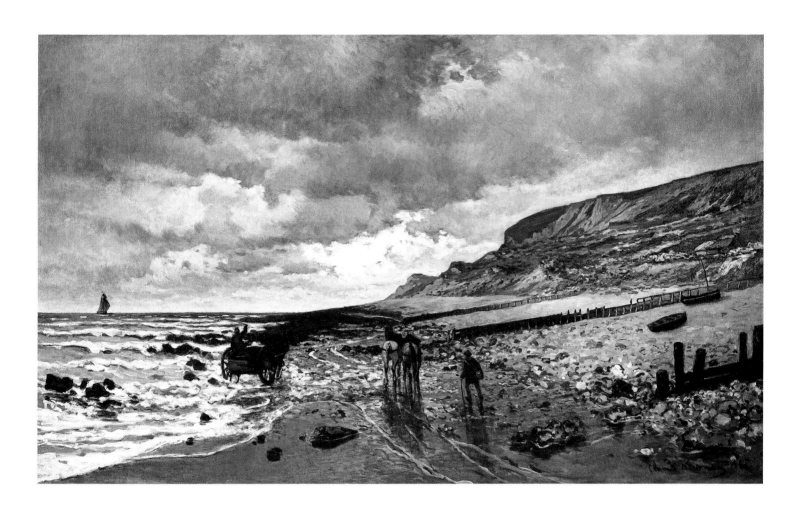

5. Claude Monet

The Headland of the Hève at Low Tide, 1865

Oil on canvas, 35½ × 59¼ inches (90 × 150 cm)
Kimbell Art Museum, Fort Worth, Texas

painting acceptable to the Salon's jury? Not in the eyes of the contemporary critics. Paul Mantz, writing for the influential *Gazette des Beaux-Arts,* remarks upon Monet's "taste for harmonious color," his "feeling for values," and his "audacious manner of seeing," while the young painter and critic Gonzague Privat declares that "the tone is frank, the breeze penetrating as on the open sea, the handling of paint naive and youthful."[7] More important than the critics' praise is their willingness to enter into the experience that the painting conjures up, to make the jump from paint and color to breeze and temperament. Although his painting results from extensive synthesis rather than a spontaneous response to a single sensory moment, Monet has succeeded at conveying a personal vision.

Alongside Monet at any of the moments imagined above, we might have found Bazille: watching over his friend's shoulder, listening to his advice, reveling in his success at the Salon. One year younger than Monet, Bazille would have been the first to describe himself as a much less accomplished artist. Whereas Monet had pursued his vocation for a number of years, exhibiting his first painting in public in 1858, Bazille had been studying medicine and indulging his passion for art and music on the side. It was only in 1864, more than a year after Bazille first met Monet, that he decided to dedicate himself entirely to painting. For Monet, the excursion to Normandy that summer meant a return to a familiar and beloved landscape and an opportunity to eke out some support from his family. For Bazille, it symbolized a new beginning, an escape from the dissection exercises and stuffy lecture halls of the medical school, and a chance to absorb not only the light and atmosphere of the seaside but also, and more importantly, Monet's example.

Let us then imagine Bazille, too, painting the beach at Sainte-Adresse looking south toward Le Havre (fig. 6, cat. 1). His picture follows closely the basic structure of Monet's (fig. 4, cat. 2): the same view of the bay and the distant city, the same pale golden light modulating to blue-green in the water and lavender-gray in the clouds. But Bazille more strongly delineates and shades his rocks and boats, even his hills and waves, producing more sense of rhythm and less of shimmering atmosphere. Whereas Monet's boats move into the depth of the picture and toward the open waters at right, Bazille's are returning toward the left, shoreward. He positions a fisherman standing and looking out at us on the shore at far left and a large sailboat moving rapidly toward us at right. Then he highlights both fisherman and sailboat with touches of dark red, bracketing the composition and accentuating those elements that remind us most forcibly of his presence—which merges with our fictional presence—before the depicted scene.

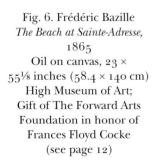

Fig. 6. Frédéric Bazille
The Beach at Sainte-Adresse,
1865
Oil on canvas, 23 ×
55⅛ inches (58.4 × 140 cm)
High Museum of Art;
Gift of The Forward Arts
Foundation in honor of
Frances Floyd Cocke
(see page 12)

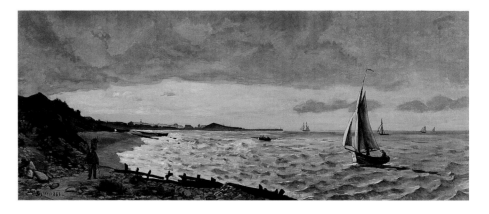

Where shall we envisage Bazille painting his seascape? He may well have accompanied Monet that day on the beach in 1864, observing the same colors in sky and water and sketching the same basic patterns and forms. But his canvas bears the date of 1865, and in terms of size, tonal range, and degree of finish, it is closer to Monet's Salon painting (cat. 5) than to the works from nature begun the summer before. Bazille's letters confirm that he painted the picture in their studio in Paris. He may have drawn upon studies and memories of his own, too, but he clearly borrowed heavily from Monet's seascape, a circumstance that may explain some of his apparent self-consciousness about his relationship to the imagined or remembered scene.[8]

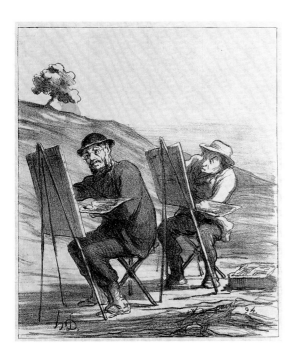

Fig. 7. Honoré Daumier
The Landscapists, 1865
Lithograph, 9½ × 8¼ inches
(24.1 × 21 cm)
The Metropolitan Museum of
Art, New York; Rogers Fund

An odd strategy, to be sure, on the part of someone who had proclaimed only the year before that as a painter he hoped to achieve at least "the merit of not copying anybody else."[9] As Bazille's words remind us, originality and copying were sensitive issues at the time, particularly in the context of landscape painting. Bazille might have been as much annoyed as amused by a caricature by Honoré Daumier that appeared when he was beginning his seascape (fig. 7). The caption for *The Landscapists* tells us that "the first one copies nature, the second copies the first." Daumier's caricature plays upon the notion, widely held at the time though less obvious to today's viewers, that painting nature in a realist manner is essentially a form of copying, as mindless and uninspired as plagiarizing another artist's work. Open-air painters such as Monet combated that attitude by emphasizing original technique and personal vision even while retaining many of the time-honored procedures and conventions of the medium.[10]

Of course, copying the works of the masters was a fundamental part of traditional artistic training, and Bazille's borrowing from his friend can be seen as an act of homage, a demonstration of his self-determined status as Monet's pupil. But Bazille was also in fact doing to Monet's picture what Monet had recently done to one of his own: transforming an open-air study into a more finished, calculated, and contained exhibition piece that might nonetheless be considered to represent an intimate response to nature. If Bazille was concerned about overstepping the bounds of acceptable practice, he may have found comfort in the fact that his seascape was intended for the private home of an uncle in Montpellier rather than for public exhibition. What was Monet's reaction? He was away working in the forest of Fontainebleau while Bazille was painting the seascape in their studio, and he may never have seen it.

The contrast between those two destinations, the Salon in Paris and the uncle's private home, not only throws into relief the two artists' relative levels of skill but also evokes their different family situations and social expectations. Monet's father, a merchant of nautical provisions in Le Havre, disapproved of his son's chosen career and determined that the young man should succeed on his own, without substantial assistance from the family. True to the mercantile ethos in which he was raised, Monet regarded sales as essential to his career, and in his early years he put much energy into cultivating personal patronage rather than banking on the reputation he could build through government

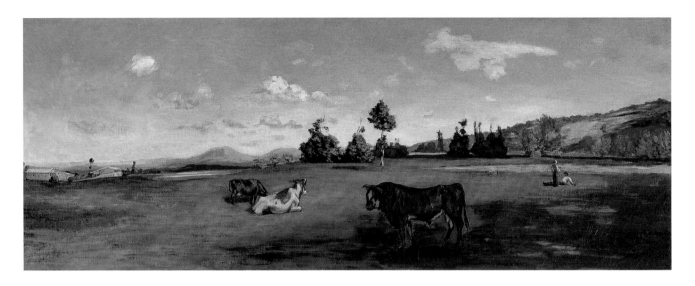

Fig. 8. Frédéric Bazille
Saint-Sauveur, 1865
Oil on canvas, 22¼ ×
58 inches (56.5 × 147.5 cm)
Private Collection

institutions such as the Ecole des Beaux-Arts and the Salon. Bazille's father, a landowner who bred and exhibited prize-winning cattle at his own expense and served as a local government official, was likewise concerned about his son's decision to become a painter. But Gaston Bazille believed in long-term planning and sacrifice for the public good, and he saw no need for a young artist to rush into selling and exhibiting before he was ready. He and other members of the family also sustained a lively interest in music, theater, and pageantry, and they seem to have viewed the world of art through the eyes of enthusiastic amateurs rather than businessmen; Bazille complained more than once that they were more interested in decorating their homes with his paintings than in encouraging him to sell them.[11]

Bazille painted *The Beach at Sainte-Adresse* between May and August 1865 for the newly built home of his uncle Eugène Pomier-Layrargues, who had lent some of the money that paid for his expenses in Paris. At the same time, he painted a companion piece, a view of the family property at Saint-Sauveur near Montpellier, in which some of the famous prize cattle—much like the boats in the seascape—punctuate and give scale to an otherwise open and fluctuating space (fig. 8). The intended placement of this pair of canvases over doorways (not an unusual practice at the time) explains their odd, wide formats. After several months of work, Bazille decided that he had provided too much detail, and he reworked his paintings to simplify them, which would have helped produce a feeling of more freshness and immediacy.[12] If Monet's *Headland of the Hève at Low Tide* had to hold its own on the crowded walls of the Salon, Bazille's overdoor paintings had to compete with the lavish furnishings of a private bourgeois home. Respectable gold frames were essential in both cases, harmonizing with the surrounding works and the decor while defining the picture as a separate space.

Both Bazille and Monet would continue to rely on the procedures they employed in their seascapes of 1864–65: reworking open-air studies in the studio, repeating and modifying their own and each other's compositions, retouching and adding signatures and frames to signify completion. Both would exhibit paintings at the Salon of 1866, and Monet would continue to sell some to private collectors. Both also would grow increasingly aware of their own roles as mediators and beholders of images, and it was in response to that awareness that their personal styles of painting would coalesce.

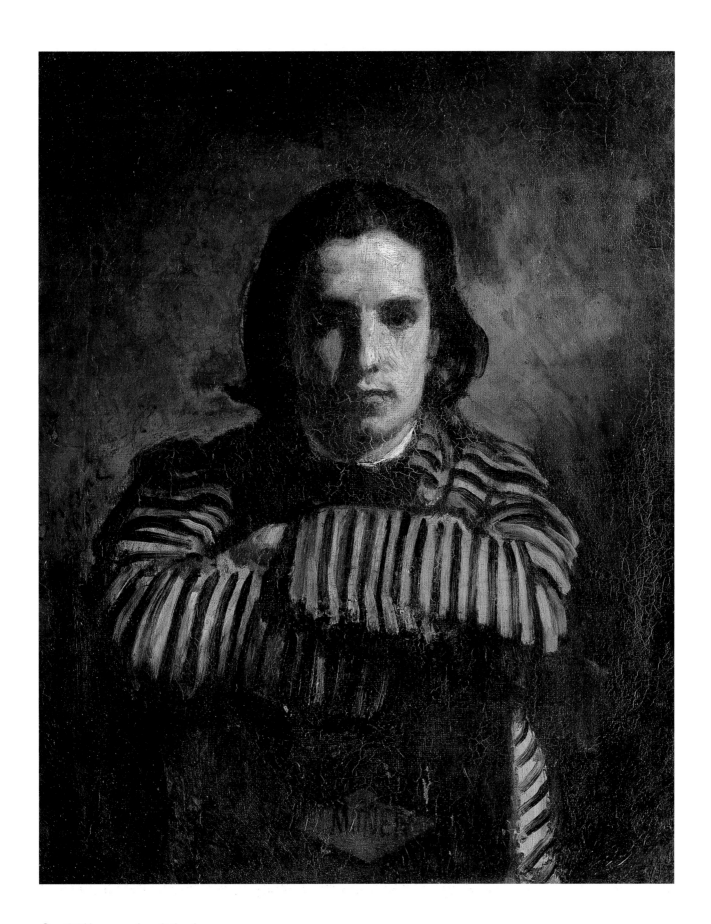

6. Gilbert de Sévérac

Portrait of Monet, ca. 1860–61

Oil on canvas, 15¾ × 12½ inches (40 × 32 cm)
Musée Marmottan, Paris

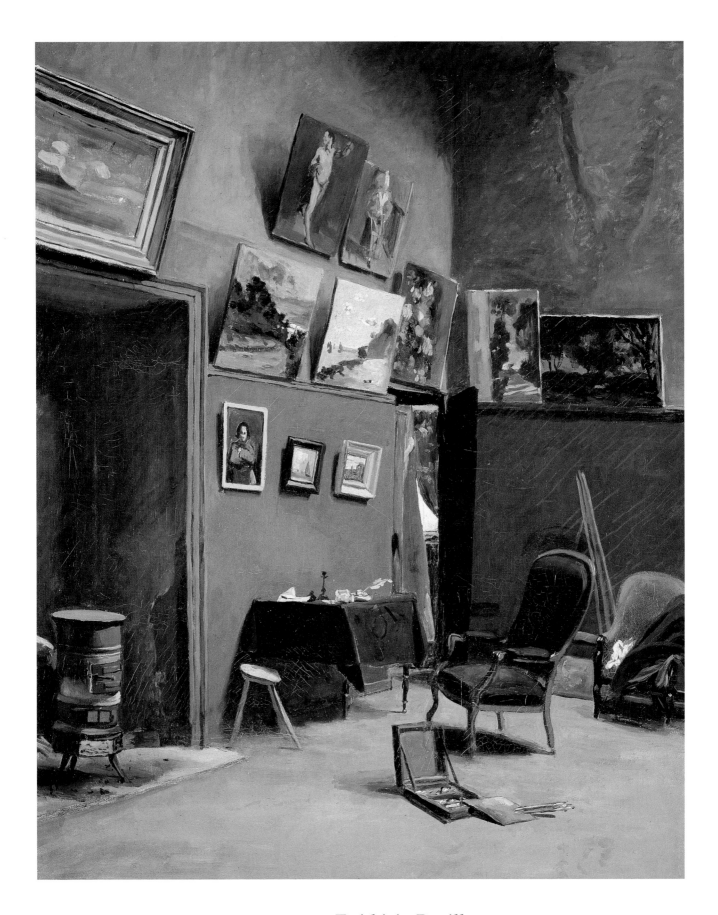

7. Frédéric Bazille

Studio in the rue de Furstenberg, 1865

Oil on canvas, 31½ × 25⅝ inches (80 × 65 cm)
Musée Fabre, Montpellier, France

Paris, rue de Furstenberg

Far from the seashore, in the shadow of the grand exhibition halls and private salons of Paris but belonging to a different social world, a small fire in a simple heating stove warms a modestly furnished room (cat. 7). A doorway in a back corner leads to a small bedroom, through the window of which one catches a glimpse of the gray winter sky. Paintings, framed and unframed, line the walls, and some brushes and a paintbox and palette of the small rectangular type favored by landscape painters have been placed casually on the floor, marking the space as an artist's studio. Austere, undecorated, with only two armchairs to suggest domestic comforts, it is a decidedly masculine space, one in which a young man can paint all day and then stay up until midnight drinking coffee and playing whist with his male companions. Women seldom visit, except for the occasional professional model who comes to pose when there is money to pay her.[13]

This is the studio that Bazille and Monet share in 1865. It is situated in the rue de Furstenberg near the center of Paris, in that area of the Left Bank, near the Ecole des Beaux-Arts and within walking distance of the Louvre, where artists have congregated for centuries. Nobody appears in the studio at the moment, but the paintings that hang there identify its occupants. A portrait of Monet by his friend Gilbert de Sévérac hangs on the wall at left, just above a small table (cat. 6). One of the unframed paintings on the wall above resembles Monet's views of the beach at Honfleur (compare cat. 3), and another to the right of the doorway can be identified as his depiction of the road to the farm at Saint-Siméon (fig. 9). Over the alcove for the stove hangs a seascape in a gold frame, sketchily rendered but reminiscent of Monet's *Headland of the Hève at Low Tide* and Bazille's *Beach at Sainte-Adresse* (cats. 5, 1), both of which were painted in this room.

It would be hard to exaggerate the importance of a studio to young artists beginning their careers. Among the other art students they met in Paris in 1863, they must have envied their friend the Vicomte Lepic, who boasted a studio in the Louvre itself, a royal privilege traditionally granted to favored artists (though Lepic actually secured it through his father, a high-ranking military officer). When Monet first arrived in Paris to study painting, he had no studio of his own, but other artists extended him the use of theirs. Bazille had pestered his parents for money to rent a studio from almost his first moment in Paris, and in January 1864 he and another student from Montpellier, Emile Villa, began sharing one in the rue de Vaugirard. But that studio had no bedrooms attached, so Bazille was obliged to lodge elsewhere, and in the meantime he was growing increasingly friendly with Monet, who

Fig. 9. Claude Monet
Road to Saint-Siméon, 1864
Oil on canvas, 32¼ ×
18⅛ inches (82 × 46 cm)
The National Museum of
Western Art, Tokyo;
Matsukata Collection

made no secret of his scorn for Villa's artistic talent. In January 1865 Bazille and Monet moved into the studio in the rue de Furstenberg, which had two small adjoining bedrooms that would allow them to live where they worked, saving money on rent and immersing themselves in painting.[14] Not only is their studio the site of most of their labor during the winter months, it also serves as a visible catalog of their collective experience and a proud symbol of their professional identity.

Of course, Bazille's painting *Studio in the rue de Furstenberg* does more than record that room in all its personal significance; it also takes its place in, and plays upon, a long tradition of depictions of artist's studios.[15] Earlier nineteenth-century examples of this popular genre often portray the studio as a mysterious, theatrical space full of outlandish costumes and erotic nude models or as a miserable garret where artists suffer for their noble cause. Other images, like Bazille's, are more sober. A brief tour of some other studios that are conceptually linked, if not always geographically proximate, will help distinguish the special character of Bazille's and Monet's endeavor.

*

An open paintbox, a palette, and some brushes rest alongside well-worn books on a small table-top; the painter seems to have stepped away from them just for a moment (fig. 10). We see no hint of a canvas in progress, and the only clue to the painter's preferred genre is a dark landscape, unframed and barely legible, hanging on the wall behind. The constricted space and the elaborately patterned wallpaper and carpet suggest not a dedicated studio space but a corner of a family home or furnished apartment that has been given over to somebody's hobby. This early painting by Monet includes no self-portrait but nonetheless evokes a strong sense of his personality. Even as he visually proclaims his profession as artist, Monet also adopts another: the diagonals of the table, brushes, and books are countered by the descending forms of a short sword, a pistol, and a rifle that hang on the wall behind and lean against the table. It is the spring of 1861, a tense moment in Monet's life: he has just chosen to face seven years of mandatory military service in order to be able to continue painting, rather than renounce his vocation, as his family wish him to do, in exchange for the money to allow him to pay for a soldier to replace him. (Ultimately, he will be discharged after only a year and a half and return to his family to convalesce from illness, and the conflict over his career will continue.) The painting itself is practically a battle cry, equating—even as it records the tension between—the tools of painting and the traditional tools of masculine heroism. Insofar as it also

Fig. 10. Claude Monet
Corner of a Studio, 1861
Oil on canvas, 71⅝ ×
50 inches (182 × 127 cm)
Musée d'Orsay, Paris

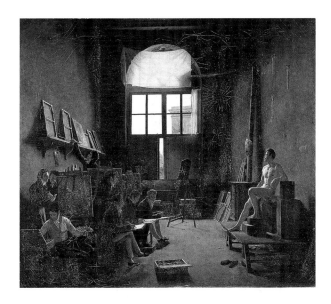

Fig. 11. Leon-Mathieu
Cochereau
*Interior of David's Studio at the
College des Quatre-Nations*, 1814
Oil on canvas, 15¾ ×
12½ inches (40 × 32 cm)
Musée du Louvre, Paris

records Monet's interest in the brightly colored, decorative patterns of the carpet and the wallpaper—a decidedly less masculine taste, according to the norms of the time—his picture of the studio prefigures his later images of his garden and lily pond at Giverny, purged of obvious symbolism but no less evocative of personal experience.

*

In a large space illuminated by high windows and furnished only with some chairs, some easels, a heating stove, and a model's stand, a nude male model poses in a stance calculated to display his muscles and suggest a dramatic event; a group of young men draw and paint him, each according to his level of training (fig. 11). The master, accustomed to working in his private studio, is not always present, but the students remain aware of his authority. The painting we are looking at in fact represents Jacques-Louis David's teaching studio in 1814, but with some updates to the fashion of the young men's clothing, it could pass for the teaching studio of Charles Gleyre in 1863, the year that Bazille and Monet met there. Gleyre's studio provided the traditional basics: professional models and a place in which to draw, paint, and practice amateur theatricals when the master was not present and to receive occasional criticism of their work when he was. As a teacher, Gleyre was a liberal, charging only modest fees and encouraging each student to develop his or her individual style.[16] As a painter, he was an eccentric: paintings such as *The Bath* of 1868 (cat. 8) betray not only his stubborn loyalty to classical subjects and highly polished rendering, but also his fascination with effects of translucency and reflection.

Just what Gleyre's studio meant to Monet and Bazille is something of a mystery. Bazille had enrolled upon first arriving in Paris to begin his medical studies in December 1862, and Monet enrolled several months later in order to satisfy the demands of his family while avoiding the more expensive and disciplined practices of other studio schools. Bazille knew himself to be a rank beginner and genuinely admired his teacher, reporting Gleyre's occasional praise with pride; Monet, however, seems to have felt from the beginning that he was superior to the other students and not really in need of formal instruction at all. A few weeks after he arrived, Monet convinced Bazille, along with two other new young acquaintances, Auguste Renoir and Alfred Sisley, to accompany him on an excursion to the countryside for the purpose of painting landscapes in the open air.[17] That event seems to have had great symbolic importance for Monet, and he (and his biographers) were later to characterize it as a rebellion against academic practice.[18] But Gleyre in fact encouraged his students to do studies in the open air, although he also made it clear that he considered landscapes to be merely, in the words of a contemporary biographer, "frames and backgrounds" for the human figures and the dramatic events proper to the superior genre of history painting.[19] In any case, Monet soon ceased to attend Gleyre's studio regularly, whereas Bazille continued for another year, right up until the moment when he and Monet left on their excursion to Honfleur and Sainte-Adresse in the summer of 1864. If the study of a nude male figure in

an academic pose that appears high on the wall in their studio (cat. 7) serves to remind them of the traditional artistic training that they had turned away from, the spare practicality of the room itself recreates some of the simplicity and open potential of the teaching studio.

*

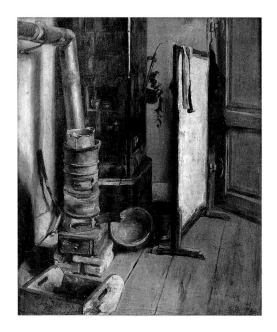

Fig. 12. Attributed to
Eugène Delacroix
Studio Corner with Stove, 1830s
Oil on canvas, 20 ×
17⅜ inches (50.8 × 44.2 cm)
Musée du Louvre, Paris

In the corner of a modestly furnished room, a fire burns in a red-hot heating stove near a freestanding portable screen (fig. 12). Once we know this is an artist's studio, the fire carries a suggestion of the importance of inner genius, and the screen hints at models clothed and naked, things hidden and revealed. Monet and Bazille probably saw this picture, which has long been attributed to Eugène Delacroix, at the posthumous sale of the master's works in 1864.[20] They made no secret of their respect for Delacroix, who was much admired in realist circles. Their mutual friend Henri Fantin-Latour had included Monet (but not Bazille, who had yet to build a reputation) in his group portrait of 1864 entitled *Homage to Delacroix* (fig. 13); Monet is the figure standing second from the right. From the window of their own studio, Bazille and Monet could see the one that Delacroix had built for himself some years earlier in the courtyard of the same building in the rue de Furstenberg, and they may have been attracted to the address for just that reason. Delacroix's example provided an important supplement and counterpart to their formal training under Gleyre. Indeed, the prominent, glowing stove in *Studio in the rue de Furstenberg* seems to be a reference to Delacroix, and the painting of abundant flowers that hangs over the door recalls the romantic master's exuberant and colorful flower compositions.[21] But Bazille's small copies of the actual canvases hanging on the wall depart significantly from Delacroix's example, conveying a fascination with the paintings themselves rather than hinting of secrets behind the model's screen.

*

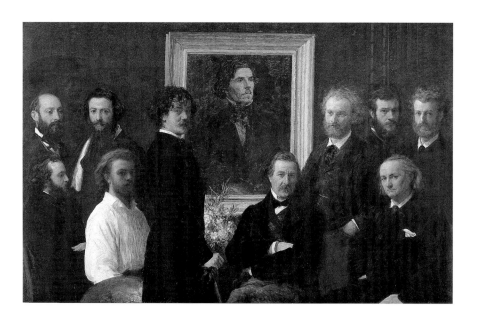

Fig. 13. Henri Fantin-Latour
Homage to Delacroix, 1864
Oil on canvas, 63 ×
98⅜ inches (160 × 250 cm)
Musée d'Orsay, Paris

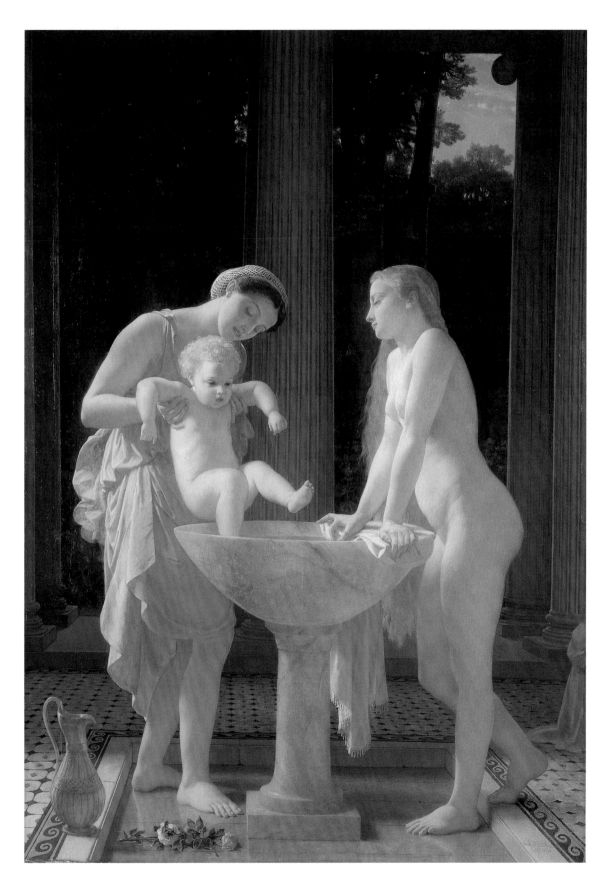

8. Marc-Gabriel-Charles Gleyre

The Bath, 1868

Oil on canvas, 35½ × 25 inches (90.2 × 63.5 cm)
The Chrysler Museum of Art, Norfolk, Virginia;
Gift of Walter P. Chrysler, Jr.

Fig. 14. Alfred Stevens
Portrait of Artist and Model,
1855
Oil on canvas, 36⅜ ×
29 inches (92.4 × 73.7 cm)
Walters Art Gallery, Baltimore

Fig. 15. James Abbott
McNeill Whistler
The Artist in His Studio,
1865–66
Oil on canvas, 24¾ ×
18¾ inches (62.9 × 47.6 cm)
The Art Institute of Chicago;
Friends of American
Art Collection

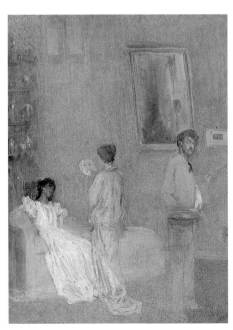

In a dim room we make out a complicated play of surfaces and shadows: a window, partly shaded; a small framed still-life painting; a framed mirror that reflects portions of the window and its shade; a tapestry; a canvas on an easel (fig. 14). This is the studio of Alfred Stevens, a Belgian painter who will later befriend Bazille.[22] The young artist himself sits contemplating that canvas, oblivious to the pretty model who stands behind him and leans over to see: his rapt absorption contrasts with her simple curiosity. Stevens has obviously drawn this self-portrait from his imagination, as if seen through someone else's eyes, rather than from his image in a mirror. (In fact, the conception draws upon one of the most famous studio images of the century, Ingres's *Raphael and the Fornarina,* which also characterizes painting as an activity that seduces the artist away from the more tangible pleasures of life.[23]) Out of the dominant warm dark colors emerge the vivid highlights of the model's yellow dress, the luminous green shade in the window, the bright blue collar of the artist's shirt, and a daub of intense vermillion on his palette. This studio is a place of mystery, where the unseen emerges into the light, and where contemplation and reverie matter more than mere physical labor.

*

An artist stands with brush and palette in hands, looking out at us—or more accurately, looking at his own reflection in a mirror—and apparently painting on a canvas just out of our sight to one side (fig. 15). On the wall behind him, framing his head, hang a small painting and a large mirror; next to a collection of porcelain displayed on some shelves, two women are relaxing and ignoring him. J. A. M. Whistler's depiction of his studio rearranges the constituent parts of his other paintings of the time: the pictures within pictures and mirrors within pictures that have become trademarks of his style; his favorite models and props now, as it were, unposed and off-duty. Bazille may have met the flamboyant Whistler and certainly would have heard about him through their mutual friend Fantin-Latour; in fact, Whistler appears standing to the left of center in Fantin's *Homage to Delacroix* (fig. 13), and it was in response to Fantin's group that he painted this picture of his studio, a study for a larger painting that he never completed. Would that version have been so mysterious? In the present painting, the small picture on the wall remains indistinguishable, as if to remind us of the difficulty of repeating images within images, whereas the mirror reflects only a fluid, silvery light shaded to reddish brown, and in so doing acts as a small repetition or summary, in terms of color and format, of the whole painting. Indeed, it is the right size and shape to be the mirror that the painter must be looking at while painting this image of himself, though its placement on the back wall is, in that scenario, an impossibility. Or perhaps a deliberate manipulation to suggest that there is no mirror in front of the artist, and that he somehow really is looking out of the picture directly at us. Or a reminder that all paintings are like mirrors within mirrors, always more or less removed from a reality that can never be pinned down.

It is hard to imagine that a more "finished" version could be as evocative as this study, in which the ambiguities of painting threaten to dissolve the image altogether.

<p style="text-align:center">*</p>

The studio that Bazille shares with Monet and the picture of it that he delineates with almost documentary clarity (cat. 7) differ subtly from the other examples we have seen. What matters most is neither the dedicated simplicity of the lifestyle depicted nor the proud assertion of the power of the brush, although Bazille alludes to both of those themes. No sensuous model tries (unsuccessfully, as the convention requires) to distract the artist from his work, characterizing painting as an act of passion and intruding upon the male camaraderie implied by the two armchairs. Nor does the artist himself appear within the private world depicted on the canvas, although the paintbox, palette, and brushes in the foreground stand in for him, as they did in Monet's picture (fig. 10). Instead, Bazille links the world of the studio with ours. The depth and emptiness of the room remind us all the more strongly of the painter who stood before the canvas, and we sense his presence not in the picture but in the space we share with him.

To be sure, Monet appears in effigy—in fact, the portrait of him by Gilbert de Sévérac seems to stare straight out at us right though its frame, while images of specific paintings refer to his oeuvre. And indeed, the most striking difference between *Studio in the rue de Furstenberg* and the other studios we have looked at involves Bazille's depiction of pictures within the picture. Paintings fill the room, constituting an ongoing private exhibition, and Bazille renders them differently than the other things in the studio: not as mirrors offering other vistas of the same world, nor as mysterious shadowy forms belonging to a different imaginative realm, but as real objects made of paint on canvas.[24] The studio contains almost nothing else to paint—just the paintings. Bazille shows us not a moment of introspection or physical effort, not the objects charged with personal meaning or the suggestive absences of elusive screens and shadowy frames, but the very process of repetition, variation, and quotation of other paintings upon which his art and Monet's are founded.

Chailly

In a room at the Lion d'Or Inn in the village of Chailly, on the edge of the Fontainebleau forest, two freshly painted canvases are propped against a wall (cat. 9 and fig. 16). Their makers, Monet and Bazille, stand back to compare them. Each studies the other's painting closely, well aware of the similarity in their choice of subjects (drawn from their personal experiences of modern life) and their handling of the paint (vigorous and abbreviated, Monet's more so than Bazille's). They joke for a moment, perhaps, about how the fashionably dressed young man in Monet's painting looks as if he is apologizing to his lady companion for having lost the tickets to the matinee and offering her instead a nice picnic on the grass, and about how the bedridden patient in Bazille's painting is stunned to learn that the attending physician never passed his medical exams. Facetious readings of paintings such as these abound in the popular caricatures of the time, playing upon the widespread expectation that a picture

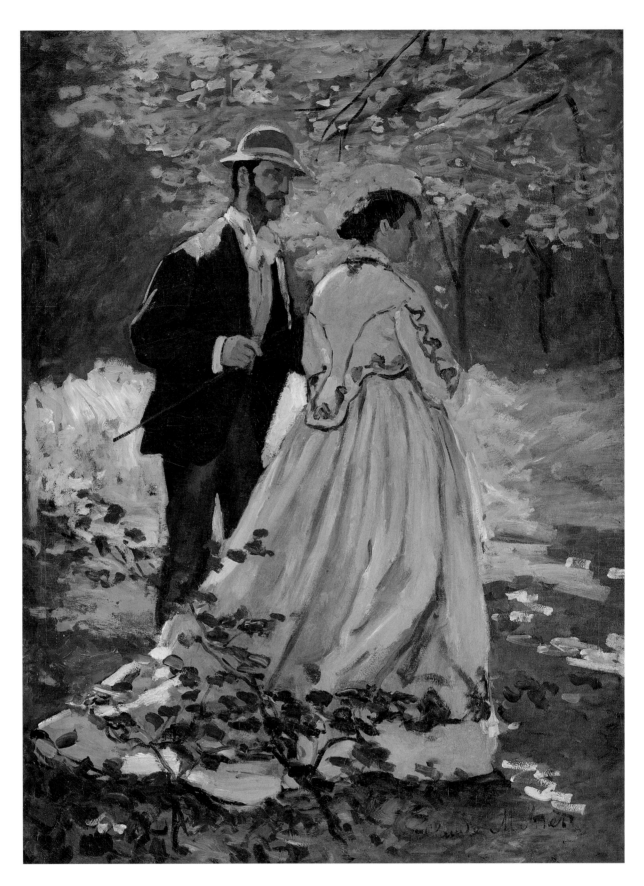

9. Claude Monet

The Strollers, 1865

Oil on canvas, 36⅝ × 27⅛ inches (93 × 68.9 cm)
National Gallery of Art, Washington, D.C.;
Ailsa Mellon Bruce Collection

tell a story, and revealing how consistently the works of important artists of the younger generation disappoint or thwart that expectation. After a moment the two friends grow more serious. Polite and generous as usual, and somewhat in awe of Monet's talent, Bazille expresses his admiration for his friend's picture. Monet, conscious of being the more experienced painter, advises Bazille to enliven his painting by juxtaposing broader strokes of contrasting colors and shades. Both observe with some satisfaction the characteristic differences between their developing personal styles, but at the same time they are aware of a strange reciprocity between the two paintings.

This scenario is imaginary, of course, but plausible enough. Certainly Monet and Bazille and the canvases in question would have been at the Lion d'Or toward the end of the summer of 1865. Monet had been staying there since April, writing frequently to Bazille in Paris and inviting him to come enjoy the lovely weather and young ladies at Chailly; in fact, Monet was falling in love with his principal female model, Camille Doncieux, whom he would eventually marry.[25] Bazille had visited briefly in May, and he returned in mid-August after finishing the seascape and the landscape for his uncle Pomier-Layrargues.

As they stand looking, each of the two painters also sees evidence of his participation in his companion's picture: each sees the image of himself and remembers posing for it. Bazille can still feel the unusual stance that Monet asked him to hold, leaning slightly forward toward the elegant figure of Doncieux, who turns away from him. Was she standing there at the same time, or did Bazille have to imagine he was addressing her? In the painting she makes no response—she is as remote and self-absorbed as a figure in a contemporary fashion plate, which indeed she resembles.[26] Whatever the case, Bazille faithfully acted out his role as model, pretending to devote all his attention to Doncieux, trying to suspend his curiosity about what Monet was doing. Monet had asked Bazille to pose because he lacked the money to pay a professional model, but he may have also appreciated the slight awkwardness of his friend's pose, which

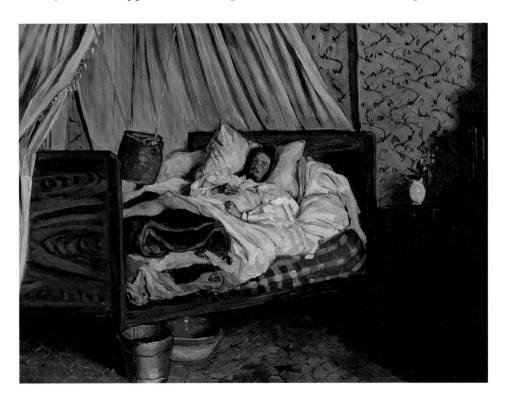

Fig. 16. Frédéric Bazille
The Improvised Field Hospital,
1865
Oil on canvas, 18½ ×
24⅜ inches (47 × 62 cm)
Musée d'Orsay, Paris

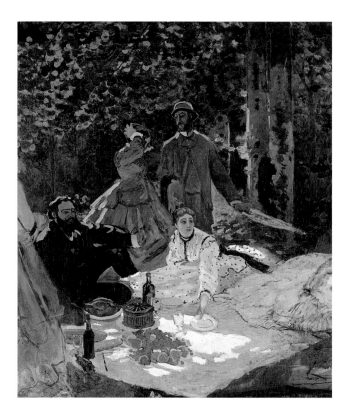

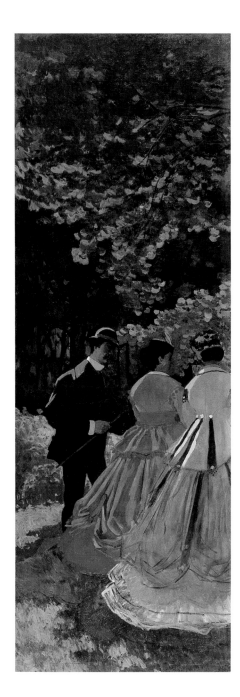

seems to capture a random, spontaneous moment and accords well
with the vigorous brushwork and large patches of unblended color.
Bazille also remembers other poses that he held for related drawings
and oil sketches by Monet (figs. 17, 18, 39): carrying some items of
clothing and an umbrella for a female companion, lounging against
a tree, reclining on the ground with his legs stretched out in front of
him. In each case, what started as a fairly comfortable, natural posi-
tion must have become less so as time passed, as Bazille grew stiffer
and his awareness shifted away from the scene he was acting out and
toward the painting on his friend's easel.

Monet produced his picture of Bazille and Doncieux and the
other sketches in preparation for his much larger *Luncheon on the
Grass,* his response to Edouard Manet's famous painting of 1862
(fig. 19).[27] Moving away from the specialized practice of landscape painting,
which had the reputation of being easy and lucrative, Monet was attempting to
combine figure and landscape in a monumental effort that would win public
recognition at the Salon.[28] That ambition helps account for the odd (and strik-
ingly modern) emptiness of several landscapes he painted that same summer
in the forest of Fontainebleau. The forest had been made famous by the group
of painters that took its name from the nearby village of Barbizon, and Monet
was acutely aware of their example. Théodore Rousseau's *Sunset over the Plain of
Barbizon* (cat. 10) combines some typical features of Barbizon landscape paint-
ing: a background of dark foliage against the sky, pierced by light and air but
screening our vision; a path leading inward to establish depth and hint at the
mystery of what lies beyond the visible; a small figure providing scale, coloristic
accent, and a bit of human interest. (The people and animals that inhabit
nearly all Barbizon landscapes function just like the boats in many seascapes,
and like the boats, they were often added during the later stages of painting.)

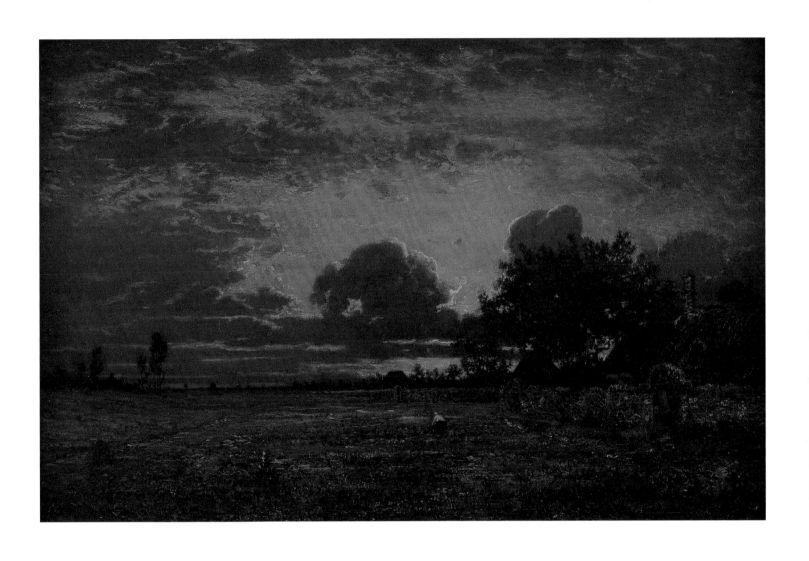

10. Théodore Rousseau

Sunset over the Plain of Barbizon, ca. 1860

Oil on canvas, 16¼ × 25¾ inches (38.7 × 65.4 cm)
Collection of Richard B. Kellam, Virginia Beach, Virginia

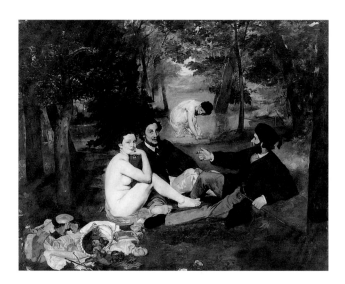

Fig. 19. Edouard Manet
Luncheon on the Grass, 1862
Oil on canvas, 81⅞ ×
104⅛ inches (208 × 264.5 cm)
Musée d'Orsay, Paris

Strikingly different from Rousseau's romantic scene are Monet's *Bodmer Oak* (cat. 11) and Bazille's *Landscape at Chailly* (cat. 12), which are structured around dense screens of foliage brought forward by thick strokes of saturated and opaque paint and which contain no living creatures at all and few compositional highlights for the eye to rest on. Bazille's landscape features a stage-like foreground of rocks and meadow against a solid backdrop of forest. Monet's painting offers a more complex interplay of surface patterning and movement into depth marked by the intervals between the trunks of three trees: the large dark oak that gives the picture its name, a smaller, smooth-barked gray tree at the center of the canvas, and, to the left, a thin white one illuminated by a gleam of light. In the context of the tradition that Rousseau represents, both Bazille's and Monet's forest scenes of 1865 are radically incomplete, mere empty frames. Incompleteness is, of course, a relative concept, but in the case of Monet's *Bodmer Oak,* it corresponds with the artist's experience. During the spring and summer of 1865, he directed all his energy toward the one goal of his *Luncheon* project, and until Bazille arrived in mid-August to pose for the male figures, he was more or less forced, by his own admission, to spend time painting uninhabited landscapes as studies for the background of his planned composition. The probable status of *The Bodmer Oak* as a study, in Monet's mind, helps account for much of its unexpected freshness.

Standing in the inn at Chailly and looking at Bazille's painting (fig. 16), Monet, too, recalls posing, although his experience was quite different. His pose offers no hint of movement, and he stares straight out of the painting as deliberately and self-consciously as can be imagined. Monet remembers the pain in his leg, badly bruised in a game of discus, the frustration of being confined to bed, the limited but welcome relief when Bazille set up a cooling device, and the combined gratitude and envy he felt when Bazille not only kept him company but took advantage of the situation to paint him. The traditional and often-repeated account of the accident that confined Monet to his bed at the Lion d'Or and prompted the painting may be riddled with clichés—it attributes criminal clumsiness to some Englishmen and credits Monet with heroically attempting to protect innocent children—but it probably approximates a real incident, accidental and unforeseen.[29]

Monet in bed would not have been an appropriate subject to submit to the Salon or sell to a collector, and Bazille's relatively traditional colors and handling of paint suggest that he painted it casually, attempting no great technical innovation, though no doubt remembering the impassive faces that gazed out of Manet's recent Salon paintings. The resulting simplicity serves him well. Monet's outward gaze seems entirely candid, justified by something other than the process of being painted even as it makes that situation vividly present to us; it achieves an almost photographic directness and makes us acutely aware of the presence of the painter before the canvas, and of our own presence that replaces it.[30] Bazille seems to have been quite intrigued by these qualities. We have seen him deploy a similar gaze, that of the fisherman, in the seascape for

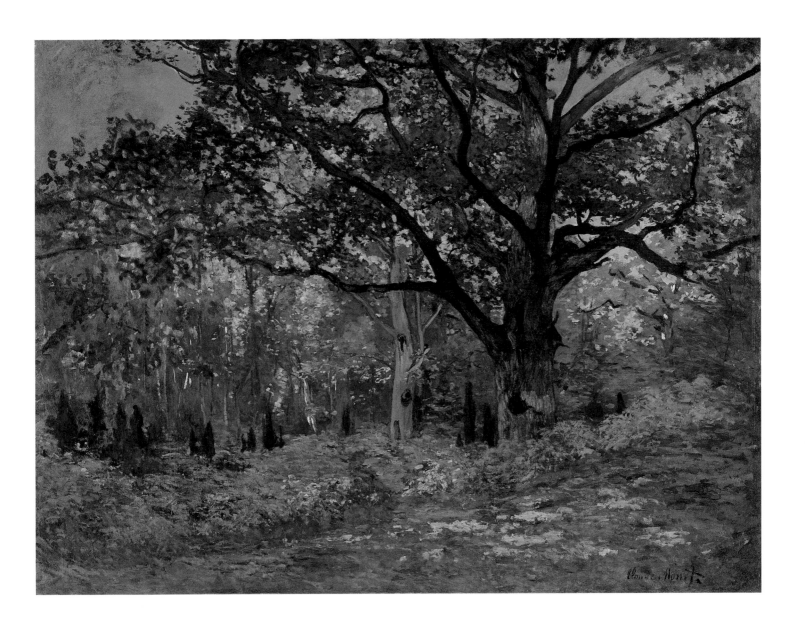

11. Claude Monet

The Bodmer Oak, Fontainebleau Forest, the Chailly Road,
1865

Oil on canvas, 37¾ × 50¾ inches (96.2 × 129.2 cm)
The Metropolitan Museum of Art, New York; Gift of Sam Salz and
Bequest of Julia W. Emmons, by exchange

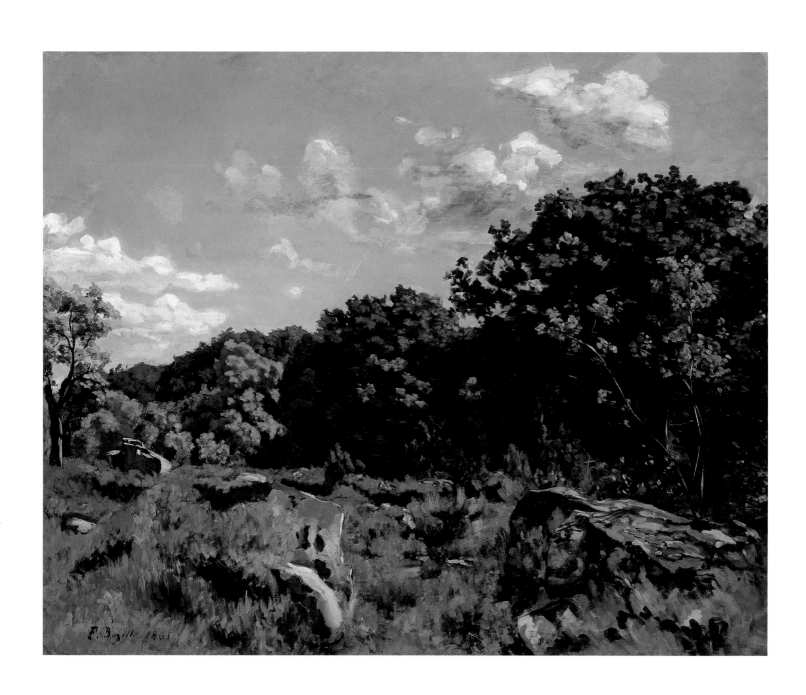

12. Frédéric Bazille

Landscape at Chailly, 1865

Oil on canvas, 32 × 40 inches (81.3 × 101.6 cm)
The Art Institute of Chicago; Charles H. and
Mary F. S. Worcester Collection

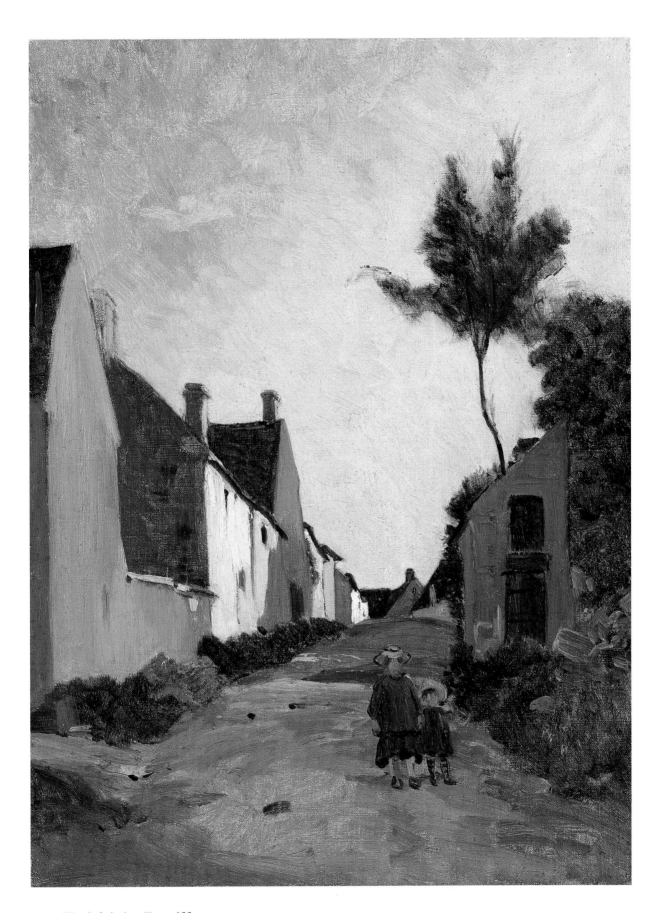

13. Frédéric Bazille

Village Street (Chailly), 1865

Oil on canvas, 12¾ × 9½ inches (32.4 × 24.1 cm)
Private Collection

his uncle (cat. 1); he repeated it again in a small picture of a street in Chailly, where two curious children peered at him as he painted (cat. 13).

Monet's study for his *Luncheon on the Grass* and Bazille's portrait of Monet at Chailly thus oddly complement one another. Monet's painting achieves an effect of spontaneity, though as part of his *Luncheon* project it demanded greater deliberation and more prolonged effort. Bazille's looks more arranged and deliberate, but the story about Monet's accident allows us to read it as a spontaneous event. Both Monet's and Bazille's pictures de-emphasize narrative—which perhaps explains why commentators have so consistently dwelt upon the anecdotal accounts of each one's genesis. Both paintings make use of the conventions of popular art forms—fashion plates and photographs, respectively—to question the nature of posing. In so doing, both call attention to the act of painting and shift the emphasis from the model in the painting to the painter standing before it.

In time, of course, Bazille's picture would cease to seem too personal to be considered anything but a student exercise and a personal memento, and Monet's fragments and studies, with their sketch-like rendering and cropped-off compositions, would cease to signify the failure of a monumental composition. All of them would be framed and treated as complete works of art, and they would be admired by audiences that the painters, as they posed for one another, could never have imagined.

Paris, rue Visconti

Just under two years later, Bazille is again painting a picture of the interior of his studio, a different studio (cat. 14). This time he positions himself before a windowless corner of the room, where pictures on the walls hang closely together and a framed painting on an easel closes off the space at one side. He works quickly on the small canvas, barely sketching in the back edge of the bench in the corner and the space between it and the heating stove behind, though he pays more attention to the books and glassware on the mantelpiece above, which he renders in tiny strokes of distinct colors. Again, he paints the canvases on the wall more loosely, covering several only with a whitish or brownish ground, and just blocking in the colors and shapes of most of the others, drawing attention to the materials and processes by which they were made. Unlike his picture of the studio in the rue de Furstenberg, no window here affords a glimpse of a world beyond, and no armchairs suggest companionship. The scene concentrates even more resolutely on the enterprise of painting, and it conveys an even more intimate sense of the artist's presence. At the bottom left corner of the picture, resting on the base of the easel, a palette (without the usual brushes) reminds us of his physical proximity—a kind of signature, perhaps, for there is no other.

The year is 1867 and the location is the rue Visconti, only a few blocks away from the rue de Furstenberg. One suspects that Bazille left the earlier studio, moving first to one on the Right Bank and then to this one, at least in part to get away from Monet. His friend's superior skill could be intimidating, and his constant requests for money threatened Bazille's own comfort.[31] But Bazille may have felt too isolated subsequently, and through the previous winter and much of the spring he has been sharing this studio with both Monet and Renoir. It is

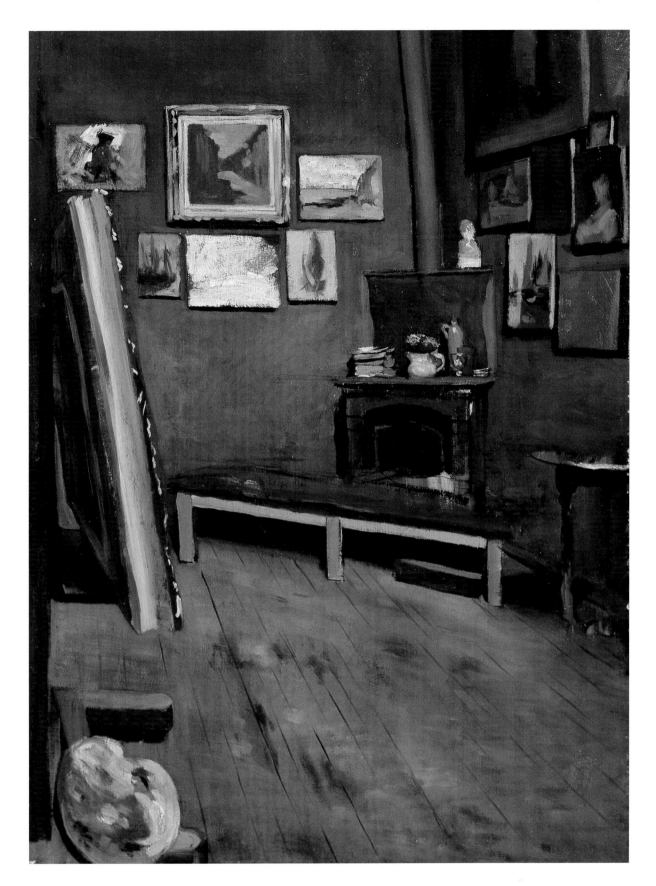

14. Frédéric Bazille

Studio in the rue Visconti, 1867

Oil on canvas, 25⅛ × 19¼ inches (64 × 49 cm)
Virginia Museum of Fine Arts, Richmond; Collection of
Mr. and Mrs. Paul W. Mellon

Fig. 20. Frédéric Bazille
Heron, 1867
Oil on canvas, 39⅜ × 31⅛
inches (100 × 79 cm)
Musée Fabre,
Montpellier, France

now May, the season of the annual Salon, and Monet has returned to the countryside. But he has left behind a number of canvases to be stored in the studio; some of them appear on the wall in Bazille's painting.[32]

A scene that we can reconstruct in this studio three or four months earlier, in January or February 1867, illustrates some of the complexity of the young artists' interactions. Bazille sits in front of his easel painting a picture of a heron, some other dead birds, and a gun arranged by a table (fig. 20). To his left, Sisley, the more elusive member of the fellowship formed in Gleyre's studio, paints a slightly different view of the same subject, handling his brush with more delicacy and using softer, more silvery tones (fig. 23). Hunting trophies are a popular theme for paintings, but the choice of subject also reflects Bazille's own fondness for the sport. Just over two years earlier he had painted the elegantly simple image of a dead sea gull hanging on a wall (cat. 15); that picture or another very like it reappears in his painting of the studio in the rue Visconti (cat. 14).[33] But no doubt the choice of a still-life subject has been determined at least in part by his lack of funds to hire models. "Do not condemn me to perpetual still lifes," Bazille writes to his mother around this time, in one of his many pleas for more money.[34]

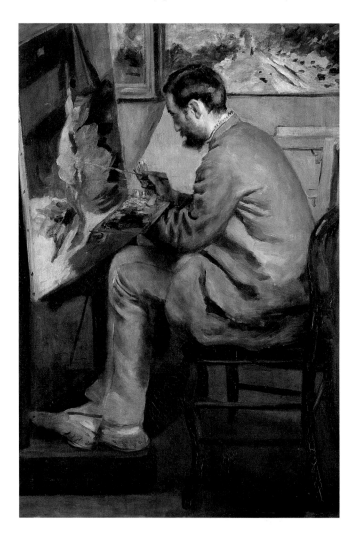

Fig. 21. Auguste Renoir
Bazille at His Easel, 1867
Oil on canvas, 41⅜ × 28¾
inches (105 × 73 cm)
Musée d'Orsay, Paris

Portraiture offers another affordable possibility. Farther back in the room, Renoir is painting Bazille at work (fig. 21).[35] More than a portrait in the conventional sense, Renoir's picture presents an image of creation in progress. Yet it differs from pictures of the contemplative artist in the studio, such as Stevens's (fig. 14), by showing Bazille actively working, touching brush to canvas. The large figure paintings that he and his friends would have preferred to be working on—such as the *Diana* that Renoir was preparing for the Salon—certainly would have had a more contrived and synthetic flavor than these simple documentary images. Bazille's, Sisley's, and Renoir's pictures of the arrangement of dead birds all convey instead a strong sense of the deliberation of studio work. Taken together, the three paintings constitute a visual conversation about the choices that painters make about what objects to include in a picture, how to arrange them, and where to situate themselves in relation to them.

The fourth member of their group, meanwhile, takes a different path. In the background of Renoir's picture hangs a canvas that looks very similar to one Monet had recently painted near Saint-Siméon (fig. 22): a landscape in which the whiteness of snow and sky contrasts sharply with the dark forms of leafless trees and the small human figures walking along a snow-covered road. The apparent simplicity of the composition and rendering and the guilelessness suggested by the human figures, who seem to approach without seeing us, convey an uncommon sense of immediacy and put pressure on the invisible barrier that we assume to exist between painting and beholder. Although Monet may be

Fig. 22. Claude Monet
Road from the Farm of Saint-Siméon, Winter, 1867
Oil on canvas, 19 × 24⅞ inches (48.3 × 63.2 cm)
Private Collection

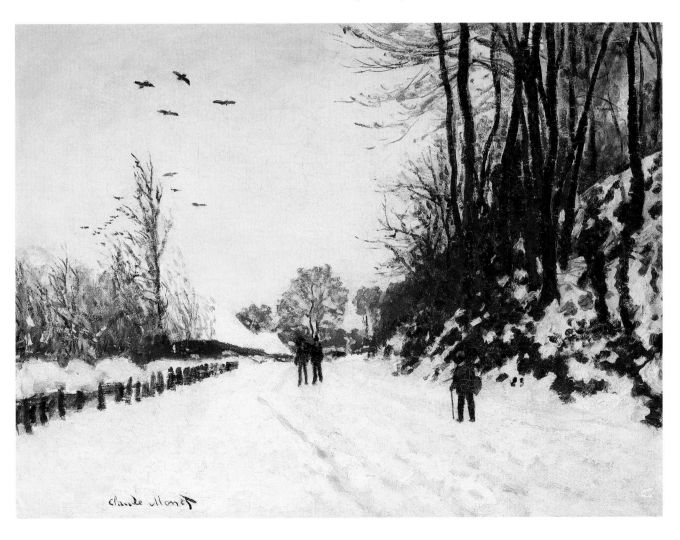

15. Frédéric Bazille

The Sea Gull, 1864

Oil on canvas, 18⅛ × 15 inches (46 × 38 cm)
Private Collection

absent from the studio, the painting that stands in for him thus expresses the essential elements of the persona he is beginning to construct for himself: the loner; the attentive eye that catches random moments rather than deliberately arranging objects to paint; the wanderer in open-air landscapes for whom the studio is a place to store paintings rather than to work. In fact, he probably touched up the snowscape, like almost all his paintings, in the studio.

Monet has been developing his particular mode of temporality and beholder engagement for some time, having retreated from the ambitious but obviously contrived character of his unfinished *Luncheon on the Grass* while continuing to explore the role of human figures in landscapes. If we could have watched him working in Honfleur during a previous summer, we might have seen him painting an unusual pair of similar views of the rue de la Bavolle (now in Boston and Mannheim, figs. 24 and 25). In these, the casual passage of time itself becomes his subject: he carefully records the numbers and positions of human figures at successive moments, not more than a few minutes apart, as revealed by the almost unchanged fall of light and shadow in the narrow street. The differences between the two paintings, and the implied interval, are much smaller than between earlier pairs such as his images of high and low tide at the headland of the Hève (cats. 4 and 5). Monet's concern with the act of perception evokes his physical presence before the scene, to which several of the human figures in one version seem to respond by looking outward (fig. 25). The effect of direct engagement between depicted subject and beholder negates and breaks through the frame, suspending our normal perception of the picture's separateness. Monet must have been thinking of the way the human figures were treated in Bazille's paintings from Chailly the year before (fig. 16 and cat. 13), although he mediates the emotional intensity of the encounter he depicts by also including within each picture some people who seem unaware of being looked at. In effect, Monet seems less self-conscious than Bazille about his position before the scene, or perhaps more accurately, his self-consciousness about being there is one of the elements that fluctuates through time (it is more evident in the Mannheim picture, fig. 25, than in the Boston picture, fig. 24).[36]

There also exists a third and quite different version of *Rue de la Bavolle,* one that retains only the general shapes and colors of the shaded and sunlit buildings and the street. No human figures appear in this version, and we feel nothing of the effects of instantaneity and engagement with the artist-beholder that the earlier canvases explore. This is Bazille's small repetition of one of Monet's two pictures (it is impossible to say which), set off from the other canvases around it by its gold frame and its central position on the wall of his studio (cat. 14). Bazille gives us only the background or empty stage, as it were, for Monet's drama of time and human interaction. He could have chosen to copy

Fig. 24. Claude Monet
Rue de la Bavolle, Honfleur,
1866
Oil on canvas, 22 × 24 inches
(55.9 × 61 cm)
Museum of Fine Arts, Boston;
Bequest of John T. Spalding

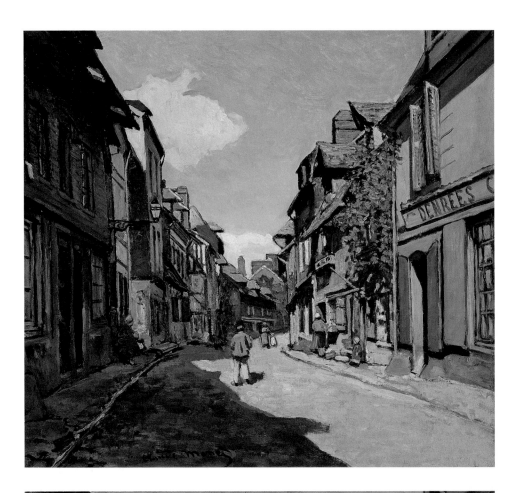

Fig. 25. Claude Monet
Rue de la Bavolle, Honfleur,
1866
Oil on canvas, 22⅞ × 24⅞
inches (58 × 63 cm)
Städtische Kunsthalle,
Mannheim

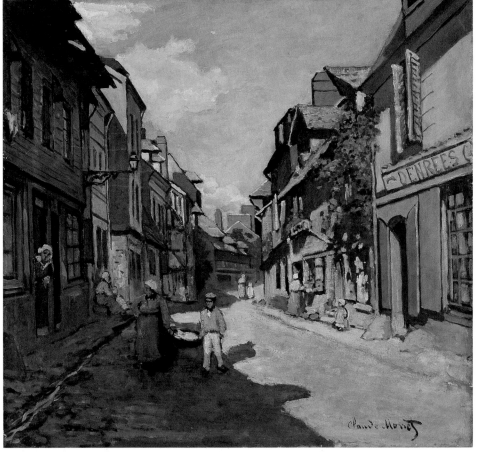

Monet's painting in much greater detail, but instead his sketchy rendering presents it, like each of the other pictures in the studio, as a tangible, paint-covered canvas. The emptiness, the obvious paint, the depicted gold frame, and the surrounding space of the studio that provides another sort of frame all underline the deliberate artifice that went into the making of Monet's apparent momentary encounter with reality.

A week or two after painting the picture of his studio in the rue Visconti, Bazille once again borrows Monet's composition, this time inserting it into an entirely different visual context.[37] Having traveled south to his native Montpellier, he sets up his easel outside the nearby Mediterranean coastal town of Aigues-Mortes. On a large canvas he paints the view down a narrow street, with sunlit facades at right and small figures moving in various directions, framed within the stone walls of the town (cat. 16). Landscape painters such as Corot often exploited what one critic in 1866 described as the "effect of distant sunlight in a frame of shadow."[38] But Bazille uses this convention distinctively. He reduces the sunlit framed scene to a tiny picture-within-a-picture, and he correspondingly expands the shaded framing zone, which acquires something of the feeling of contemplative intimacy that invests his studio spaces. Exaggerating the difference between the two zones of the landscape in terms of scale and light, Bazille then links them by painting some rays of sunlight spilling out through the open city gate. The effect is startling: a flood of bright light and warm color from within an otherwise cool and shaded space; a burst of outward movement into an otherwise calm and slow-moving scene. Now it is the manipulation of the framing device rather than the gazes of the human figures that makes the picture seem to be actively, indeed almost tangibly, addressing us. In his later large outdoor compositions, Bazille will again stress the paradoxical, flattening effect of shaded foreground against brightly illuminated background, problematizing the usual relationship between figure and ground (see, for example, figs. 36 and 47 and cat. 20). Rather than bracketing or quoting Monet's composition, as he has already done in his picture of the studio in the rue Visconti, Bazille now transforms and naturalizes it along with the implied frame that defines its relationship to our space.

While Bazille is painting at Aigues-Mortes, Monet, back in Normandy, also experiments with framing devices within paintings. Setting up his easel once again on the beach at Sainte-Adresse, he employs a bright, light-toned palette and higher viewpoints. These differ markedly from the romantic, slightly melancholy colors and deep space of his own canvases of 1864–65 (cats. 2–4 and fig. 5), reflecting instead the influence of another nontraditional art form, the Japanese print. Monet also pays considerably more attention to the boats and human figures, which become major players in the composition rather than mere punctuating afterthoughts. In one painting (fig. 26), he arranges the large, dark forms of fishing boats pulled up on the sand quite unconventionally: he crops one group abruptly at left, and he centers another group in the foreground, forming a tight visual cluster with boats sailing in the water beyond. On another canvas depicting a regatta of sailboats on the bay and spectators who watch from the shore (fig. 27), he pushes the boats at right and the human figures at left close to the two sides of the canvas, reinforcing the framing edge while emptying out the central space of blue water and sky. Most surprising, in both paintings he depicts human figures whose fashionable costumes identify

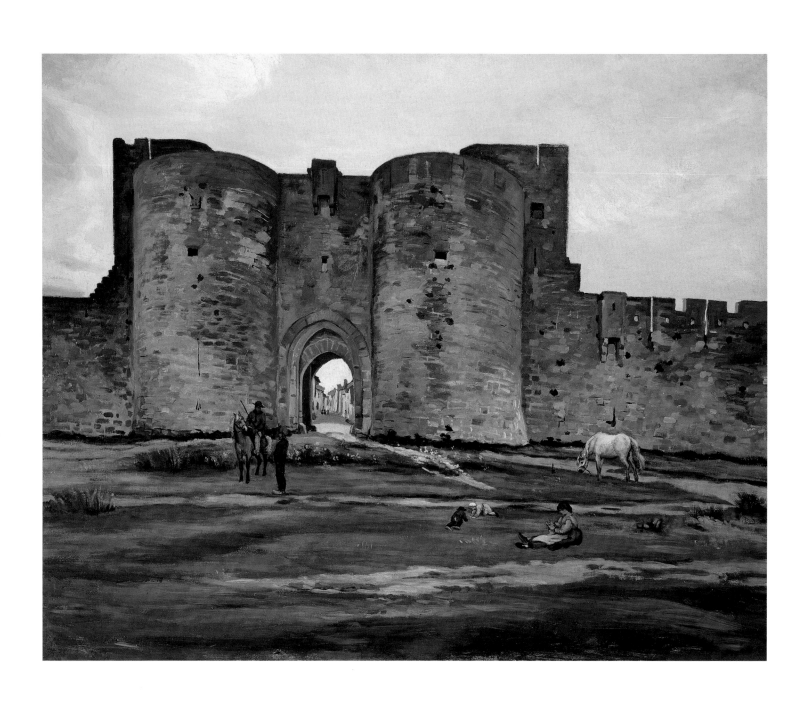

16. Frédéric Bazille

The Queen's Gate at Aigues-Mortes, 1867

Oil on canvas, 31¾ × 39¼ inches (79.4 × 99.7 cm)
The Metropolitan Museum of Art, New York; Purchase,
Gift of Raymonde Paul, in memory of her brother,
C. Michael Paul, by exchange

Fig. 26. Claude Monet
Beach at Sainte-Adresse, 1867
Oil on canvas, 29½ × 39⅝
inches (75 × 101 cm)
The Art Institute of Chicago;
Mr. and Mrs. Lewis Larned
Coburn Memorial Collection

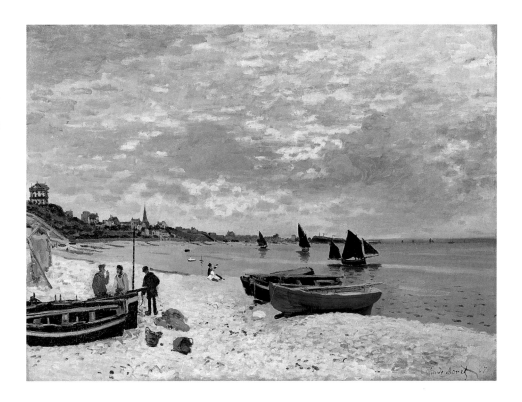

Fig. 27. Claude Monet
Regatta at Sainte-Adresse, 1867
Oil on canvas, 29⅝ × 40
inches (75.2 × 101.6 cm)
The Metropolitan Museum of
Art, New York; Bequest of
William Church Osborn

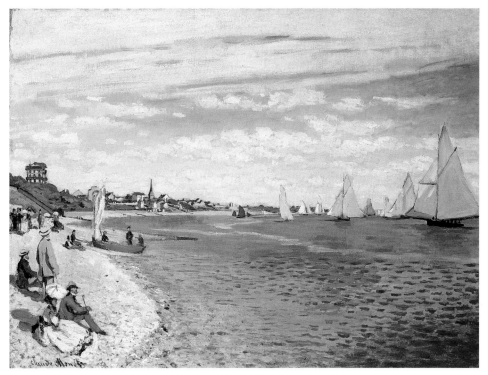

them as middle-class individuals involved in leisure activities, in striking contrast to the fishermen, workers, and villagers who almost exclusively populate the usual images of rural scenes, including Barbizon forest scenes and Monet's own earlier views of towns and beaches. The tourists on the beach belong to the same social class as Monet himself and the patrons he hoped to attract.[39] Strongly identified with the probable beholders of the picture, the beholders within each picture thus become detached from the rest of the scene, which seems more random and accidental, and which they look at without participating in. They are almost as much a part of the frame as of the picture; they

remind us that we, too, are part of the picture's framing, and that our act of beholding can both reaffirm and call into question its status as a work of art.

In the next few years, between the Salon of 1867 and the outbreak of the Franco-Prussian War in the summer of 1870, Bazille's career takes off just as Monet's begins to stall, while Monet's financial difficulties and family obligations increasingly strain their friendship. They spend less time together and draw upon different artistic sources. Still, they continue to respond actively to one another's paintings. Thus Bazille's *Family Gathering* of 1867–68 (fig. 47) can be understood as his answer to Monet's *Women in the Garden* of the year before (fig. 41), which Bazille purchased just before beginning his own picture and kept with him while he worked. Both paintings feature people in contemporary costumes taking their leisure in landscape settings, and both respond with great sensitivity to the flattening contrast of bright sunlight and shade. But the differences between them recapitulate the contrast between the figure paintings the artists made at Chailly in 1865 (cat. 9 and fig. 16). Monet presents anonymous figures absorbed in their own activities, whereas Bazille gives us exact portraits of family members whose poses and gazes testify to the presence of the artist before the canvas and the fact of being painted. Monet's picture fragments time while Bazille's freezes and extends it; Monet's conveys a sense of accident while Bazille's conveys deliberation. Subsequently, their interchanges become more complex. In the paintings they prepared for the Salon of 1869, it is Bazille, in his *View of the Village* (cat. 20), who depicts an anonymous young lady in a landscape that no longer simply frames but almost engulfs her, and it is Monet, in his *Luncheon (Interior)* (fig. 44), who takes on the theme of family portraiture, marking his own ambivalent relationship to the portrayed group with the empty chair and the foreground that opens into our space.[40] Then in *Summer Scene* of 1869 (fig. 36), another large Salon piece, Bazille entirely suppresses the direct outward gaze, disposing his figures in poses that at once quote from paintings in the Renaissance tradition and convey a sense of awkward, self-conscious immediacy.[41] Around the same time, Monet begins to produce smaller, more casual pictures that deploy the outward gaze even while transforming it into an almost accidental moment and softening its psychological impact (for example, fig. 53). The dialogue between them continues to animate their art even as they grow further apart.

But let us return again to the studio in the rue Visconti in May 1867 (cat. 14), before Bazille went to Aigues-Mortes and Monet went to Sainte-Adresse. Bazille is painting a picture we cannot see, or more precisely he is painting an image of a picture we cannot see: the framed canvas on the easel at left in the view of the studio, which he has positioned so as to display not the painted surface but the frame itself and the back side of the canvas. An artist might place a framed picture on an easel for several reasons: to present it for special inspection by friends and guests in his studio; to touch it up for an exhibition; or simply to store it temporarily until he found another place for it. Or these reasons might succeed one another, as in the case of Bazille's *Terrace at Méric,* the large painting that he prepared for, submitted to, and saw rejected by the Salon of 1867, which has usually been identified as the unseen canvas on the easel. Indeed, more than one newly refused painting would have found its way back to the rue Visconti that spring. The jury of the Salon, protective of France's reputation during the year of an International Exhibition, had acted particularly

conservatively, and Monet's *Women in the Garden* (fig. 41), Renoir's *Diana*, and indeed all of their entries met with the same fate as Bazille's *Terrace at Méric*.[42]

For the young painters, those refusals constituted a serious crisis. At least some of their works had always been accepted in previous years, and they had been depending on the Salon to provide an audience for their paintings, not only to enhance their reputations and secure patronage, but also to allow comparison with other artists' work and to solicit criticism. The refusals threatened their identities as painters and their sense of whom they were painting for. Bazille drafted a letter of protest, which Monet, Renoir, and many others also signed, calling for the government to sponsor an exhibition of the refused works. At the same time, they began to plan a group exhibition of their own for the following year, inspired in part by the independent solo shows that Courbet and Manet were in the process of setting up.[43] But they soon realized that a favorable response from the government would not be forthcoming and that the dreamed-of independent exhibition was far beyond their financial means. They helped one another as best they could, but that was no long-term solution: thus, for example, Bazille's purchase of Monet's refused *Women in the Garden* for 2,500 francs (payable in 50-franc monthly installments) would cause tension between them, not only because Monet would always hope for larger payments than Bazille would be able to make, but also because he must have hoped to see his painting gaining broader exposure in the hands of an influential patron.

By the end of May, the two friends would take a decisive step away from the Salon system by exhibiting their pictures in the window of the paint merchant Louis Latouche, a precursor to the art dealers who were soon to proliferate in Paris. In subsequent decades, while the idea of an independent group show was to bear fruit in the Impressionist exhibitions, it was the collaboration with dealers that would establish a new and viable support system for artists and decisively influence their choices of subjects and formats and the development of their personal styles.[44] But when Bazille was painting his studio in the rue Visconti, he and Monet must have feared that their paintings might never find an audience. The picture on the easel in the studio, framed but nonetheless incomplete because unseen, eloquently expresses that anxiety.

The crisis of audience that the two friends experienced in the spring of 1867 made obvious something that was already deeply implicated in their work: an awareness of the congruent yet never identical roles of the artist and the beholder. By means of their diverse strategies of compositional framing, repeating, enclosing, and occluding, Bazille and Monet accentuate the making, and the viewing, of the paintings themselves.

Inside/Outside

It is 1870, and Bazille is painting a picture of his studio in the rue La Condamine, in the Batignolles district at the northern edge of Paris, which he has occupied since 1867 (fig. 28).[45] Renoir lives there too, and they share not only spaces but also materials: for the current picture, for instance, Bazille is reusing a canvas that contains what seems to be a study for an earlier work by Renoir.[46] Once again he provides a catalogue of the pictures in the studio: his Salon entries of 1867 and 1869, some paintings by Monet and Renoir, several of his own recent

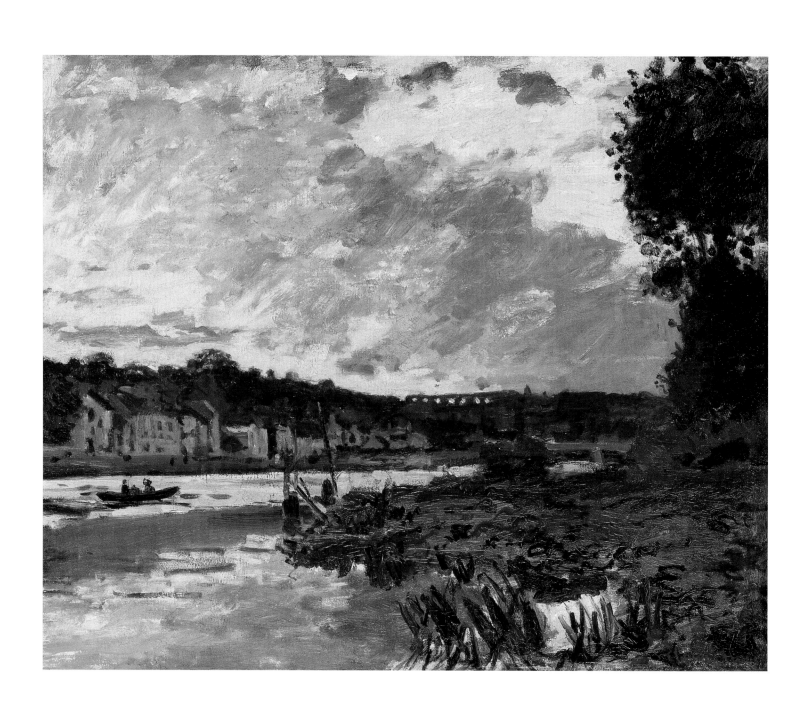

17. Claude Monet

The Seine at Bougival in the Evening, 1869

Oil on canvas, 23⅝ × 29 inches (60 × 73.5 cm)
Smith College Museum of Art, Northampton,
Massachusetts; Purchase

works in progress, and a group of framed and unframed canvases leaning against the wall at left that could be in almost any state of completion or incompletion.[47] But this time Bazille makes visible a social component that he merely hinted at in his earlier pictures of studios. He portrays friends—artists, critics, amateurs— conversing, looking at a painting on an easel, playing the piano.[48] (One of the

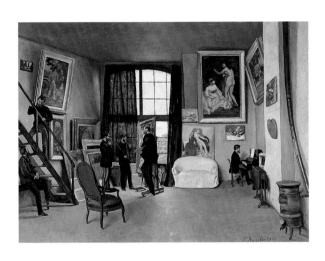

figures by the stairs at left probably represents Monet, who is still storing paintings there but living with Doncieux and their child outside of Paris.) Finally, Manet lends a hand and paints in a portrait of Bazille, all but blocking our view of the framed painting on the easel at the center of the room.[49] If the physical history of this canvas reveals a particularly close degree of collaboration between painters, its imagery emphasizes the artistic and social interaction within the group of friends that constitutes the original audience for his art.

A few years later, after Bazille's death, Monet stands before a portable easel in the open air, painting a flowering garden. The canvas he is working on is turned at an angle that prevents us from seeing its front surface,

Fig. 28. Frédéric Bazille
*Studio in the rue
La Condamine,* 1870
Oil on canvas, 38⅛ ×
50 inches (97 × 127 cm)
Musée d'Orsay, Paris
(see page 73)

but it no doubt resembles his other landscapes of recent years. Already in 1869, in his striking *Seine at Bougival in the Evening* (cat. 17), he was applying paint in even more vigorous and varied strokes that mimic the moving surfaces of earth, sky, and water, dissolving them into one another, and he was composing with simplified rectangular masses that defy the conventions of internal framing. Monet has begun to concentrate on the more random and instantaneous slice of the field of vision that will characterize his Impressionist style. Standing before the easel in his garden, he pursues that goal, and he seems not to notice

Fig. 29. Auguste Renoir
*Monet Painting in His
Garden,* 1873
Oil on canvas, 18⅛ × 23⅝
inches (46 × 60 cm)
Wadsworth Atheneum, Hartford, Connecticut; Bequest
of Anne Parrish Titzell

that he is being painted by Renoir (fig. 29). (Is Monet consistently unwilling to pose for his friends, or do they dare paint him only when other circumstances, like the accident at Chailly in 1865, keep him relatively immobile?) Renoir depicts the mythical lone painter in the open air, face to face with unmediated nature, and this is of course the image that Monet will cultivate for the rest of his career. No hint of the deliberation of studio work creeps in, even though the landscape that Renoir observes Monet working on, like most of his paintings, will no doubt be touched up in the studio afterward.[50]

"My studio! But I never have *had* one, and personally I don't understand why anybody would want to shut themselves up in some room." Monet's famous statement of 1880 is not only unjust to the memory of his friendship with Bazille, it is strictly inaccurate, and it is disingenuous about the nature of his own art.[51] In another sense, though, his statement parallels his style of painting, which makes use of skilled craft and patient work to give the illusion of immediate and unmediated moments of perception, and manipulates framing devices to provide a fluid and unselfconscious vision. These qualities make Monet's Impressionism accessible to a broad modern audience. But they are always founded in and sustained by the deliberation, the acknowledged collaboration, and the acute self-consciousness that come to the fore in Bazille's work. Monet's slices of life and open-air spontaneity and Bazille's quotations and studio contemplations are deeply implicated with one another, as complementary and conceptually interdependent as any picture and frame.

Notes

The abbreviation S. identifies letters by the numbers assigned in Michel Schulman, *Frédéric Bazille, 1841–1870: Catalogue raisonné* (Paris: Éditions de l'Amateur, 1995).

1. S. 90 (Monet to Bazille, 14 October 1864). In Monet's and Bazille's surviving correspondence, there are several mentions of frames to be ordered, shipped, stored, and reused; see, for example, S. 85, 91, 130, 150, and 212. Stuckey points out that despite Monet's sustained interest in frames, today none of his paintings are known to be in frames he provided. Charles F. Stuckey, *Claude Monet, 1840–1926* (Chicago: Art Institute of Chicago; New York: Thames and Hudson, 1995), pp. 17–18.

2. S. 91 (Monet to Bazille, 16 October 1864).

3. For the history of frames, see Paul Mitchell and Lynn Roberts, *A History of European Picture Frames* (London: Merrell Holberton, 1996); and Eva Mendgen, ed., *In Perfect Harmony: Picture + Frame, 1850–1920* (Amsterdam: Van Gogh Museum; Vienna: Kunstforum Wien, 1995).

4. Most recent philosophical discussions of the problem of the frame respond to Jacques Derrida's seminal deconstructive treatment *The Truth in Painting* (Chicago: University of Chicago Press, 1987). Two I have found particularly useful: Jean-Claude Lebensztejn, "Starting Out from the Frame (Vignettes)," in *Deconstruction and the Visual Arts: Art, Media, Architecture*, ed. Peter Brunette and David Wills (Cambridge, England: Cambridge University Press, 1994), pp. 118–40; and Louis Marin, "The Frame of Representation and Some of Its Figures," in *The Rhetoric of the Frame: Essays on the Boundaries of the Artwork*, ed. Paul Duro (Cambridge, England: Cambridge University Press, 1996), pp. 79–95. For perceptive comments on the studio as "first frame," see Daniel Buren, "The Function of the Studio," *October* 10 (fall 1979): 51–58. On painting and beholder in the eighteenth and nineteenth centuries, see especially Michael Fried's trilogy *Absorption and Theatricality: Painting and Beholder in the Age of Diderot* (Berkeley and Los Angeles: University of California Press, 1980); *Courbet's Realism* (Chicago: University of Chicago Press, 1990); and *Manet's Modernism, or The Face of Painting in the 1860s* (Chicago: University of Chicago Press, 1996).

5. On Monet's (and Bazille's) painting techniques in the 1860s, see especially Kermit Swiler Champa, *Studies in Early Impressionism* (New Haven: Yale University Press, 1973). On Monet's fascination with water and for a characterization of his relationship to painting as narcissistic, see Steven Z. Levine, *Monet, Narcissus, and Self-Reflection: The Modernist Myth of the Self* (Chicago: University of Chicago Press, 1994).

6. I use the terms "sketch" and "study" loosely here, without meaning to imply any particular expectation about the "final" form a picture might take, because I believe this use corresponds best to Monet's practices as opposed to the more precise academic procedures of the time.

7. Paul Mantz, "Salon de 1865," *Gazette des Beaux-Arts* 19 (July–Dec. 1865): 26; and Gonzague Privat, *Place aux jeunes! Causeries critiques sur le salon de 1865* (Paris: F. Cournol, 1865), p. 190.

8. Most commentators agree in seeing Bazille's seascape as a studio copy of Monet's rather than an original work painted out-of-doors. He might have begun it at Sainte-Adresse in 1864 and finished it back in Paris in 1865, but this seems unlikely, given the large size and unusual shape of the canvas and given that Bazille wrote that all of his paintings from Honfleur and Sainte-Adresse had been ruined during the return trip to Paris; see S. 80 (Bazille to his mother, June or July 1864).

9. S. 63 (Bazille to his father, January 1864); compare S. 90 (Monet to Bazille, 14 October 1864).

10. On the impossibility of an absolute distinction between open-air and studio work, see especially Peter Galassi, *Corot in Italy: Open-Air Painting and the Classical-Landscape Tradition* (New Haven: Yale University Press, 1991), ch. 1. On originality and technique, see Robert L. Herbert, "Method and Meaning in Monet," *Art in America* 67, no. 7 (Sept. 1979): 90–108; and Richard Shiff, *Cézanne and the End of Impressionism: A Study of the Theory, Technique, and Critical Evaluation of Modern Art* (Chicago: University of Chicago Press, 1984).

11. On Gaston Bazille's involvement with pageantry, see for example S. 194; for instances of the family wanting to hoard paintings, see S. 117, 126, 215, 219, and 271.

12. S. 109 (Bazille to his mother, May 1865) and 119 (Bazille to his mother, August 1865).

13. Given the dates of occupation and the season that seems to be depicted, Bazille most likely painted his *Studio in the rue de Furstenberg* either in January–March or November–December 1865. The former range seems more likely, given that there is no sign of the works he and Monet would have brought back from Chailly in the fall (cats. 9 and 11–13 and figs. 16–18). On the Latin Quarter as a "distant colony" of the Right Bank, see S. 23 (Bazille to his parents, January 1863). For the layout of the apartment, see Gabriel Sarraute, "Catalogue de l'oeuvre de Frédéric Bazille" (thesis, Ecole du Louvre, Paris, 1948), p. 31. For a characterization of studio images by Fantin-Latour and Bazille as exclusively masculine spaces, see Tamar Garb, "Gender and Representation," in Francis Frascina et al., *Modernity and Modernism: French Painting in the Nineteenth Century* (New Haven: Yale University Press, 1993), pp. 233–36. Bazille describes evenings of coffee and whist with his friends in S. 101 (Bazille to his mother, winter 1865).

14. On Lepic, see S. 32 (Bazille to his father, March 1863). On the custom of granting artists studios in the Louvre, see Jacques Lethève, *Daily Life of French Artists in the Nineteenth Century* (London: Allen and Unwin, 1972), pp. 44–45. The still-life painter Charles Monginot, an acquaintance of Boudin's, had offered Monet the use of his studio in 1859; see Monet's letter to Boudin, 3 June 1859, in Gustave Geffroy, *Monet, sa vie, son oeuvre* (1924; reprint, Paris: Macula, 1980), pp. 26–29. On Villa, see S. 56 (Bazille to his mother, November 1863) and 82 (Monet to Bazille, 15 July 1864). For the dates of Monet's and Bazille's occupation of the studio in the rue de Furstenberg, see S. 97 (Bazille to his mother, December 1864) and 126 (Bazille to his brother, December 1865).

15. On the history of depictions of the artist's studio, see Jeannine Baticle and Pierre Georgel, *L'atelier: technique de la peinture* (Paris: Editions des Musées Nationaux, 1976); David B. Cass, *In the Studio: The Making of Art in Nineteenth-Century France* (Williamstown, Mass.: Sterling and Francine Clark Art Institute, 1981); and Michael Peppiatt and Alice Bellony-Rewald, *Imagination's Chamber: Artists and Their Studios* (Boston: New York Graphic Society, 1982).

16. On Gleyre's teaching, see especially Albert Boime, "The Instruction of Charles Gleyre and the Evolution of Painting in the Nineteenth Century," in *Charles Gleyre ou les illusions perdues* (Zurich: Schweizerisches Institut für Kunstwissenschaft, 1974), pp. 102–24; and William Hauptman, "Delaroche's and Gleyre's Teaching Ateliers and Their Group Portraits," in *Studies in the History of Art*, vol. 18 (Hanover, New Hampshire: University Press of New England, 1985), pp. 79–119. On Gleyre's female pupils, see Paul Milliet, *Une famille de républicains fouriéristes*, vol. 2 (Paris: Giard and Brière, 1915–16), p. 125.

17. On their stay in Chailly in 1863, see S. 33–35 (Bazille to his father and to his mother, March–April 1863).

18. For Monet's account of escaping Gleyre's studio, see for example his interview with Marcel Pays in *Excelsior* (26 January 1921), reprinted in Geffroy, *Monet*, p. 36.

19. Emile Montégut, "Charles Gleyre," *Revue des deux mondes* (15 September 1878): 411: "he saw almost nothing in nature but frames and backgrounds" ("il ne voyait guère dans la nature que des encadrements et des fonds"). Gleyre's attitude about landscape no doubt reinforced Monet's and Bazille's ambition to combine figure painting and landscape.

20. Lee Johnson, *The Paintings of Eugène Delacroix: A Critical Catalogue*, vol. 1 (Oxford: Clarendon, 1981–86), p. 242.

21. Flower painting was a common practice at the time. Villa, Bazille's previous studio-mate, was known as a painter of still-life and animal scenes, and Bazille's first painting in the studio they shared was of flowers. Monet also was fond of painting flowers; he described one of his own pictures of them, which he exhibited in Le Havre in 1864, as his best painting to date, and he advised Bazille to paint them too. S. 64 (Bazille to his mother, February 1864), 82 (Monet to Bazille, 15 July 1864), and 86 (Monet to Bazille, 26 August 1864).

22. William A. Coles, *Alfred Stevens* (Ann Arbor: University of Michigan Museum of Art, 1977), cat. no. 3; and William R. Johnston, *The Nineteenth-Century Paintings in the Walters Art Gallery* (Baltimore: Walters Art Gallery, 1982), pp. 153–54. Stevens was a friend of Bazille's uncle Hippolyte Lejosne, Baudelaire, and Manet. He returned repeatedly to the theme of the artist in his studio, but his later works depict the studio less as a site of mystery than as a fashionable microcosm of high society. Bazille included critical comments on Stevens's art and personality in S. 227 (Bazille to his mother, February 1869) and 231 (Bazille to his father, March 1869).

23. For Ingres's multiple versions of *Raphael and the Fornarina*, see especially Patricia Condon et al., *In Pursuit of Perfection: The Art of J.-A.-D. Ingres* (Bloomington: Indiana University Press, 1983).

24. The use of a different facture for the rendering of pictures within pictures is peculiarly characteristic of a group of painters associated with Impressionism; see Baticle and Georgel, *L'atelier: technique de la peinture*, p. 50. For a historical survey of pictures within pictures, see Pierre Georgel and Anne-Marie Lecoq, *La peinture dans la peinture* (Dijon: Musée des Beaux-Arts, 1983).

25. See especially S. 108 (Monet to Bazille, 4 May 1865) and 121 (Bazille to his father, August 1865).

26. On Monet's use of fashion plates, see Mark Roskill, "Early Impressionism and the Fashion Print," *Burlington Magazine* 112 (1970): 391–95; Joel Isaacson, *Monet: Le déjeuner sur l'herbe* (London: Penguin Press, 1972), pp. 47–51; and Paul Hayes Tucker, *Claude Monet: Life and Art* (New Haven: Yale University Press, 1995), pp. 23–24.

27. The genesis and meaning of Monet's painting are explored in depth in Isaacson, *Monet: Le déjeuner sur l'herbe.*

28. On landscape's reputation as easy and lucrative, see for example Jules Antoine Castagnary, "Salon of 1857," in *Salons*, vol. 1 (Paris: Charpentier, 1892), pp. 2–48.

29. Gaston Poulain, *Bazille et ses amis* (Paris: Renaissance du Livre, 1932), p. 56.

30. For the relation between Bazille's painting and photography, see Dianne W. Pitman, *Bazille: Purity, Pose, and Painting in the 1860s* (University Park: Pennsylvania State University Press, 1998), ch. 3.

31. Bazille moved to a studio in the rue Godot-de-Mauroy in January or February 1866, and in July 1866 he moved again to the rue Visconti. S. 126 (Bazille to his brother, December 1865) and 149 (Bazille to his mother, summer 1866).

32. S. 156 (Bazille to his parents, winter 1867), 158 (Bazille to his mother, February–March 1867), 167 (Bazille to his father, May 1867), and 168 (Monet to Bazille, May 1867).

33. *The Sea Gull* has usually been identified as the painting of the "white bird" mentioned in S. 117 (Bazille's mother to Bazille, August 1865).

34. S. 151 (Bazille to his mother, December 1866).

35. Schulman dates Bazille's *Heron* and Renoir's portrait of Bazille to 1868 because that is the date that has usually been assigned to S. 192, a fragment in which Bazille describes a still life with a heron as a work in progress. Although Bazille did not date the letter, its contents establish that it was written while he was finishing a painting he intended to submit to the annual Salon, probably between January and early March. In that letter, Bazille also mentions that he is working on his self-portrait in his "Méric painting" and a picture of flowers for his cousins the Teulons. These are usually taken to be his *Family Gathering* (fig. 47) and his *Flowers* (Grenoble, Musée de Peinture et de Sculpture), both of which are dated 1868. But there are problems with that interpretation. For one, both Bazille's *Heron* and Renoir's portrait of Bazille are signed and dated 1867, a fact that Schulman unaccountably ignores in his discussions of them. For another, Bazille used the phrase "Méric painting" in successive years to refer to whichever large canvas he had begun the previous summer, so S. 192 could be referring to *Terrace at Méric* (Geneva, Musée du Petit Palais), which he was finishing in the winter of 1866–67 and which also contains a figure traditionally identified as a self-portrait. As for the painting for the Teulons, Bazille indicates in the same letter that he is not sure if he will give it to them. Part of the confusion stems from the fact that the *Flowers* that he eventually gave them, which is dated 1868, was formerly thought to be one of the paintings that he exhibited at the Salon of 1868 and thus necessarily finished by March of that year, but that has been disproven by Guy Barral; it may not have been finished until the autumn of that year, at which time Bazille obtained a frame for it (see S. 212). In their joint catalogue, Gary Tinterow and Henri Loyrette assign different dates to Bazille's *Heron* (November–December 1867) and Renoir's portrait (winter–spring 1867); however, it seems unlikely that Bazille would have repeated a subject so exactly on two occasions. Colin Bailey, recognizing a problem, dates both works to the autumn of 1867, which, however, does not seem to fit the season indicated in the letter. The only reasonable conclusion is that S. 192 must have been written, and the paintings must have been painted, in the early months of 1867. See Schulman, *Frédéric Bazille*, pp. 167–68 and 363; Guy Barral, "Bazille et Montpellier," in *Frédéric Bazille, traces et lieux de la création* (Montpellier:

Musée Fabre, 1992), p. 17 n. 19; Gary Tinterow and Henri Loyrette, *Origins of Impressionism* (New York: Metropolitan Museum of Art, 1994), pp. 332–33 and 452; and Colin B. Bailey, *Renoir's Portraits: Impressions of an Age* (New Haven: Yale University Press; Ottawa: National Gallery of Canada, 1997), pp. 100–103.

36. Joel Isaacson, *Claude Monet: Observation and Reflection* (Oxford: Phaidon; New York: Dutton, 1978), pp. 13 and 194–95; idem, "Observation and Experiment in the Early Work of Monet," in *Aspects of Monet,* ed. John Rewald and Frances Weitzenhoffer (New York: Abrams, 1984), pp. 20–22. Isaacson dates the paintings to 1864, but recently Tinterow has argued that they probably date to 1866: Tinterow and Loyrette, *Origins of Impressionism,* pp. 422–23 (where they are mistakenly associated with Bazille's *Studio in the rue La Condamine*).

37. S. 170 (Bazille to his mother, May 1867).

38. Maxime Du Camp, "Le Salon de 1866," in *Les Beaux-Arts à l'exposition universelle et aux salons de 1863, 1864, 1865, 1866, & 1867* (Paris: Jules Renouard, 1867), p. 204. Du Camp is commenting on a painting by Jean-Léon Gérôme. On Bazille's sustained rivalry with Gérôme, see Pitman, *Bazille,* pp. 14–15, 24–28, and 48–49.

39. On *The Beach at Sainte-Adresse* and *Regatta at Sainte-Adresse,* see especially the insightful comments of Robert L. Herbert, *Monet on the Normandy Coast: Tourism and Painting, 1867–1886* (New Haven: Yale University Press, 1994), p. 11; and Shiff, *Cézanne and the End of Impressionism,* pp. 108 ff. Monet comments on the paintings he did at Sainte-Adresse at this time in S. 171 (Monet to Bazille, June 1867). See also Zola's remark of 1868 that Monet seems unable to paint pictures without including in them a bit of dressy modernity; discussed in Tucker, *Claude Monet,* p. 3.

40. In 1869, Monet decided not to submit his painting to the Salon at the last minute; in 1870, he submitted it only to see it refused. On Monet's *Luncheon,* see especially Anne M. Wagner, "Why Monet Gave Up Figure Painting," *Art Bulletin* 76 (Dec. 1994): 613–29.

41. The introduction of quotations from the art of the past is not so antithetical to Bazille's quest for beholder engagement as it may seem at first. As Leo Steinberg points out, obvious quotation can be a strategy to give viewers a sense of intimate access to the artistic process. Leo Steinberg,

"Introduction: The Glorious Company," in Jean Lipman and Richard Marshall, *Art About Art* (New York: Dutton, 1978), p. 14.

42. Bazille's *Terrace at Méric* is now in the Musée du Petit Palais, Geneva; Renoir's *Diana* is in the National Gallery of Art, Washington, D.C.

43. S. 161 (Bazille to Monsieur le Surintendant des Beaux-Arts, 30 March 1867), 162 (Bazille to his mother, March–April 1867), and 169 (Monet to Bazille, 21 May 1867).

44. S. 167 (Bazille to his father, May 1867) and 171 (Monet to Bazille, 25 June 1867). On Latouche, see Geffroy, *Monet,* pp. 69 and 468 n. 7. On the changing structure of patronage, see especially Michael Moriarty, "Structures of Cultural Production in Nineteenth-Century France," in *Artistic Relations: Literature and the Visual Arts in Nineteenth-Century France,* ed. Peter Collier and Robert Lethbridge (New Haven: Yale University Press, 1994).

45. Bazille moved to the Batignolles in December 1867, and he left it in April 1870 for a studio in the rue des Beaux-Arts in the Latin Quarter: S. 186 (Bazille to his mother, December 1867) and 263 (Bazille to his father, 1 January 1870). Rue La Condamine was called rue de la Paix until August 1868, and that is how Bazille refers to it in most of his correspondence, becoming aware of the change only in December 1869; see S. 260 (Bazille to his mother, December 1869). He executed the painting of the studio in December 1869 and January 1870; see S. 258 (Bazille to his father, December 1869) and 263 (Bazille to his father, 1 January 1870).

46. An X-ray of *Studio in the rue La Condamine* that reveals the overpainted sketch is reproduced in *Renoir* (London: Hayward Gallery; Paris: Grand Palais; Boston: Museum of Fine Arts, 1985–86), p. 60, fig. 5.

47. Bazille's *Terrace at Méric,* his Salon entry of 1867, is visible at far right. His 1869 entries were *Fisherman Casting a Net* (fig. 32), which hangs on the wall at left, and *View of the Village* (cat. 20), on the easel. Behind the easel and unframed is his *Young Woman with Lowered Eyes* (private collection). *La Toilette* (fig. 49) appears in its still-unfinished state, hanging over the sofa next to a still life of fruit by Monet. Above the latter is a composition of two women probably painted by Renoir.

48. I identify the painting on the easel as Bazille's *View of the Village* (cat. 20). We can make out the left edge (open sky above, a dark green tree emerging from

some lighter ones, and part of a white dress at the bottom) and the top and bottom right corners (dark green foliage and a bit of red sash respectively). On this point I disagree with Champa (in this volume), who identifies it as Bazille's *Summer Scene* (fig. 36).

49. S. 263 (Bazille to his father, 1 January 1870). For the identities of the people in Bazille's *Studio in the rue La Condamine,* and in particular the identity of the man standing behind Manet as the critic Zacharie Astruc rather than Monet, as has sometimes been argued, see Pitman, *Bazille,* pp. 185–86.

50. Bailey, *Renoir's Portraits,* pp. 122–23. For another comparison of Bazille's *Studio in the rue La Condamine* and Renoir's *Monet Painting in His Garden,* see Meyer Schapiro, *Impressionism: Reflections and Perceptions* (New York: George Braziller, 1997), p. 267. Whereas Schapiro stresses the evolution of artists' self-images, I want to emphasize also the contrast between two distinct artistic personalities.

51. Emile Taboureux, "Claude Monet," *La vie moderne* (12 June 1880), reprinted in *Monet: A Retrospective,* ed. Charles F. Stuckey (New York: Levin Associates, 1985), pp. 89–93.

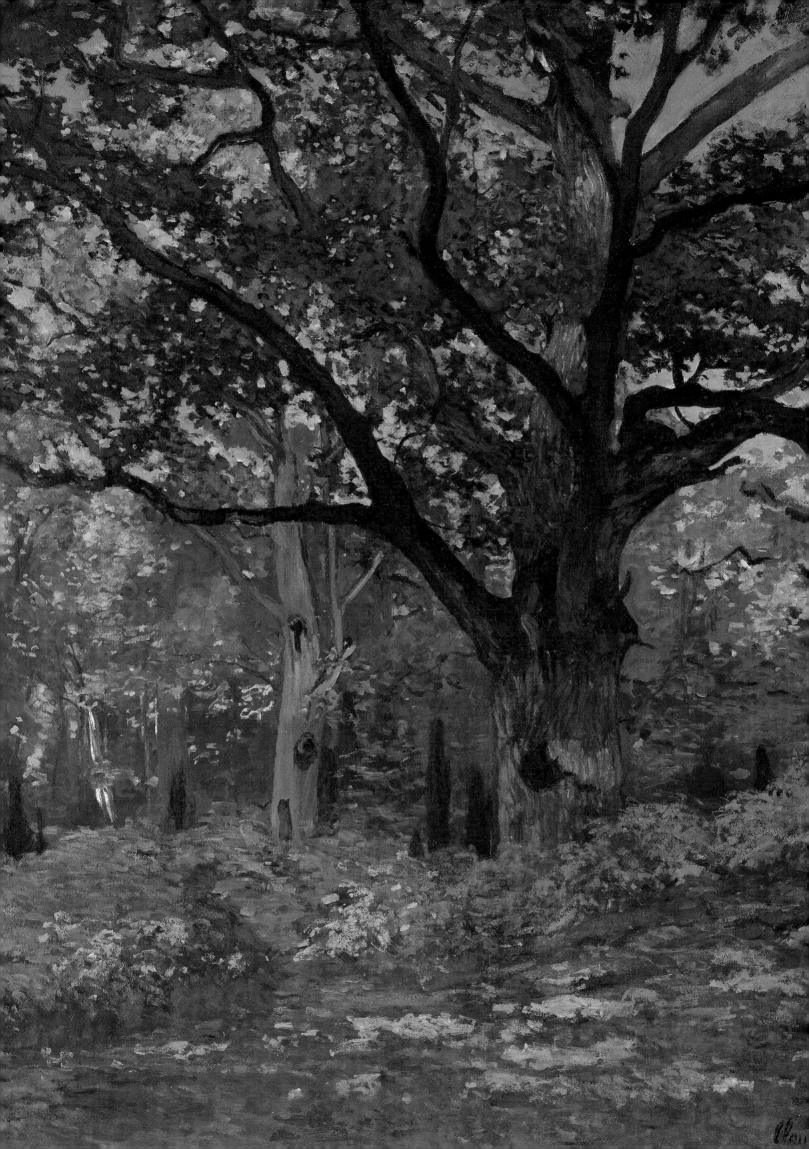

A Complicated Codependence

Kermit Swiler Champa

In any modern account of French painting during the decade of the 1860s, the names of Claude Monet and Frédéric Bazille are invariably linked. The principal reason for this linkage is a tantalizing body of correspondence (nearly three hundred items) that was first mined by the French scholar Gaston Poulain in his 1932 book *Bazille et ses amis*.[1] Working with letters carefully preserved by Bazille's family, Poulain pieced together the detailed outlines of the artist's relationships with his painter friends (especially Monet). The largest group of letters was from the artist to his parents, but equally significant were a group of letters from Monet to Bazille from 1863 through 1869 and a much smaller group from Renoir to Bazille. Unfortunately, there were virtually no indications of the correspondence Bazille dispatched. But given the letters Poulain had, there was sufficient available material of a documentary sort to attempt an early revisionist look at the 1860s—one that featured the artist most nearly forgotten, Bazille. Poulain's title indicates his project: Bazille was his focus; Monet and Renoir were Bazille's friends.

The decades since Poulain's book have seen the publication of far more complete transcriptions of the letters, presented less polemically and more as straightforward historical documents of a firsthand sort.[2] The wide circulation of the letters written by Bazille (even their translation into English) has produced a situation only hinted at by Poulain. The letters, standing by themselves, have provided temptations (and hurdles) that every scholar confronting them has had to address, whether undertaking to interpret Bazille's accomplishment, or Monet's, or any other significant realist efforts by French painters after 1860. Although not all interpreters have found the letters equally useful, or useful in the same ways, the letters seem highly present in scholarship, even when they are not specifically cited.

What the Letters Suggest: A Paraphrase

For purposes of the present exhibition, which suggests through the display of paintings produced by Monet and Bazille the visual outlines of their relationship (both personal and artistic), the existence of the letters and the narratives they contain need to be kept firmly in mind to explain why the Monet-Bazille relationship can be understood to constitute a significant mini-discourse within the larger context of what was arguably French painting's most excitingly conflicted decade. What is being exhibited in this essay is a text that has two tightly interconnected

elements: a visual one and another equally (if not more) important one that exists in the letters.

The Monet-Bazille text, provocative as it is, remains, as do all historical matters, highly incomplete. Many paintings by both artists have been lost or destroyed. Similarly, the letters constitute only a fraction of the written record that once existed. Already mentioned is the absence of Bazille's side of the correspondence with his painter friends, particularly with Monet. Equally, the correspondence received by Bazille from his family exists only as a shadow. This being the case, one is faced, whether looking at the paintings or reading the letters, with a highly suspect picture of events and ambitions. And the most complete section of the picture, the letters from Bazille to his family, is likely the most unreliable. Correspondence between a financially dependent son and parents anxious to have their professional priorities honored is bound to be governed by all manner of evasion, self-justification, half-truths, and pronounce-ments the parents want to hear. The Bazille portrayed to his parents in the let-ters is a hardworking medical student who sustains the cultural interests valued by his family—interests in serious music and theater—and who at the same time dutifully undertakes a sub-career in painting.

The parental letters, taken as a coherent project of cautious self-definition and incipient independence, seem to have an agenda of their own, namely to soften the blow of a son's radical change in professional focus from respectable medicine to less respectable painting. The letters attempt (and seem to do so successfully) to make the transition both a natural and reasonable one. Bazille was a cunning writer, judging from these letters, but their content was highly determined, and nothing like a reliable outline of his operations as an artist per se can be expected from them. Bazille obviously reported what was acceptable and useful to his parental manipulation and avoided anything that might sug-gest risk or uncertainty. Except for the predictable pleadings for additions to his routine financial assistance, the letters are (as artists' letters go) remarkably upbeat.[3] Ever the good son, the letter-writing Bazille reads as a loyal family member, always eager to sustain his ties with a wide range of relatives in both Paris and Montpellier—the latter being his hometown and the center of his activities every summer.

In spite of the highly tactical nature of the parental correspondence, which makes it prima facie unreliable in professional matters overall, there are of course many hints regarding Bazille's maneuvers as an artist that filter through. Reports of who he is associating with and why, opinions of his contemporaries (characterized very generally), his self-promotional strategies, something of his day-to-day routine in the art world—these appear throughout the letters, but they never come close to describing in any nuanced way the priorities of feel-ing and vulnerability that might offer a "complete" Frédéric Bazille. One of the significantly underemphasized patterns of Bazille's life appearing in the paren-tal letters is his support, financial and otherwise, of his colleague and friend Monet. This and the absence of any clear representation of the art-political minefields of Paris in the 1860s can be seen to suggest exactly how edited for positive consumption the parental letters actually were.

Monet's letters to Bazille are a totally different matter. They are as complex in strategy as the parental letters are straightforward. Bazille's relationship with his parents was, for want of a better word, natural. His letters were undertaken

to sustain the financial security of that relationship and (quite genuinely, one suspects) to honor familial feelings and values. Monet's letters to (and his relationship with) Bazille are a more artificial construction. The coefficients of affection and/or of convenience never seem absolutely clear. Judging from what Monet writes to Bazille, it is difficult to gauge some very basic things. How did Monet view Bazille as an artist, for example? Did he respect or simply tolerate what Bazille was diligently producing?

From the earliest letters, Monet presents himself as the model "working artist," insisting that Bazille join *him* in order to engage in serious work.[4] From the moment the two artists met in 1863 in the teaching studio of the Parisian-Swiss painter Charles Gleyre, Monet appears to have insisted, very self-righteously, on the sincerity of his work. This insistence was directed at a prime target in the person of Bazille, who was struggling in the mid-1860s to sustain some semblance of routine in his medical schooling while at the same time attempting to test himself as a painter. Monet, on the other hand, had been stubbornly contesting the will of his father and painting constantly for four years by 1863. His work in Gleyre's studio seems to have been an attempt to mend family fences (at least up to a point) by appearing to be proceeding in a conventional professional fashion, while at the same time operating, in fact, as a highly ambitious realist autodidact.

When Bazille met Monet, he met an aspiring artist who, while financially insecure, was (probably at least in part because of that) absolutely, even desperately, committed to himself. Bazille was, it seems, destined to become Monet's first proof of a successful and superior self, at first artistically and then (assuming commercial matters developed favorably) financially as well. Monet's letters to Bazille, leaving their precise details aside, undertake (probably quite consciously) to dominate Bazille and to make him operate as a willing second in the "cause Monet."

What is truly astonishing in Monet's letters is the insistent confidence of their tone regarding Bazille's willingness, indeed his obligation, to act for Monet out of friendship and respect in virtually all matters of necessity and convenience.[5] It is probably not going too far to suggest that Monet constructed Bazille as the ideal first audience for his artistic ego, and that his letters document both this construction and the maneuvers it was understood to permit. Since most of Bazille's letters in response to Monet's seem no longer to exist, it is difficult to gauge precisely how he reacted over the years to Monet's domineering behavior. But whatever Bazille might have written it did nothing to modify the demands of Monet, who insisted on favor after favor and who in his written record becomes almost abusively angry when Bazille is hesitant (or late) in providing whatever service Monet deemed absolutely necessary. It seems that rather than resisting Monet's behavior in any serious way, Bazille willingly accepted it. It seems, in other words, that (at least at first) he needed Monet as a confident alter ego to buttress his own professional uncertainties and, for several years, his lack of ego.

The apparent situation of codependence offered a great deal to both artists. The development of Monet's established, if always slightly underground, reputation in the second half of the 1860s, his friendship with the great realist Gustave Courbet, and his competition with the decade's most controversial artist, Edouard Manet—all of this Bazille was able to enjoy vicariously while he

managed at a far more deliberate pace to position himself and *his* work for some recognition.

Before venturing beyond the admission routine of the annual government-sponsored Salon (where Monet's more independent inclinations found little sympathy), Bazille was able (even forced) to work on Monet's behalf to pursue and develop alternative exhibition and marketing routes. Keeping an inventory of Monet's work in his Paris studio, Bazille acted as an agent of sorts and a promoter, instructed carefully by Monet (when he was outside of Paris, which was frequently) to deal with potential collectors, private exhibitions (usually paint dealers), and so on.[6] By the end of the decade, Bazille was considering strategies for group exhibitions of ambitious realist work to be carried on completely outside the government-sponsored exhibition structure. When he reported these plans to his parents, he indicated that such exhibitions would be of particular benefit to artists like Monet, whom he termed in 1867 "the best of all of them." The plan coincided with Bazille's painting of a portrait of Monet to be shown in such an exhibition, were it to happen. Clearly, Bazille's promotion of Monet (which seems to have taken up the time released by Bazille's placing of his medical education on permanent hold) continued right up to the years before his death in the Franco-Prussian War and in spite of his own emergence in 1868 and 1869 as an increasingly recognized artistic newcomer with several major Salon acceptances to his credit.

One wonders how Bazille ultimately saw himself as an emerging artist in relation to Monet. How could he believe strongly in himself while sustaining his boundless support of Monet? What *were* his paintings in comparison to Monet's? The letters never really tell us, at least not the letters that remain. And what, over the decade, did Bazille gain personally and artistically from his seemingly selfless submission to the needs of his friend? Was Bazille simply bewitched, or was he acting out some strangely dedicated act of charity? Did he ever seriously resent Monet's demands?[7] There are some indications that he did, particularly concerning the payment schedule established for his purchase of Monet's radically ambitious painting from 1866–67, *Women in the Garden* (fig. 41), and concerning Monet's relentless cries of financial hardship in 1867, when his mistress (later his wife) was about to give birth.[8] But by the end of 1868, Monet was still able (in addition to persuading Bazille to write to Monet's father for help on his behalf) to enlist Bazille as the baby's godfather and to resume correspondence that remains ambivalent, even critical, in tone with regard to Bazille's efforts as an artist. Practically and psychologically, Monet kept the upper hand without, it seems, much contest.

Without considering at this point the manner in which the Monet-Bazille relationship developed with regard to the respective painting practices of both men, there remain some additional questions to be asked of the letters— questions that can produce, if not answers, at least suggestions as to the dynamics of their bond. As indicated already, the manner of friendship operative between them is difficult to gauge, but the degree of dependence appears substantial. Given this, one must look to the character of the written rhetoric that marks Monet's letters for some structural clues. The tone of Monet's written voice is almost invariably one of entitlement. Or, to put it differently, Monet assumes that his advice will be taken and his needs serviced. He speaks to Bazille almost in the manner of a conventionally demanding nineteenth-century bourgeois

husband. His demands appear to be met by Bazille in the manner of an equally conventional wife.

Does this mean that Bazille was in some basic way self-feminizing, as such might have been understood in the gender-shaky years of the 1860s when, more systematically than ever before, doctors and psychologists were classifying various forms of sexually "deviant" behavior and thereby destabilizing established notions of gender?[9] There is actually a good deal of circumstantial evidence in Bazille's letters to his parents to suggest that he had behavioral tastes that could be interpreted, in period terms at least, as being more feminine than masculine. To begin with, he appears from the time of his arrival in Paris to have been obsessed with his appearance. His clothing needs were enormous, precise, and the subject of much attention in many letters.[10] Although one could argue that Bazille's comparatively busy social schedule required much attention to dress, his degree of concern seems remarkably intense. If we compare Bazille's concern with Courbet's in the latter's parental letters of the 1840s, it is clear that two similarly social artists, both of whom liked to dress well, were very different in the actual scale of importance and attention they gave to the matter.[11] Courbet never belabors the issue of dress; Bazille definitely does.

Conventional dress is not the only form of dressing that is discussed in Bazille's letters. He seems never to have missed an opportunity to participate in amateur theatrical performances in the mid-1860s. His descriptions in letters to his parents invariably emphasize his costumes and sometimes the gender ambiguity they signaled.[12] Bazille obviously liked to be seen "dressed" and to be the focus of the appearance-interested gaze. More than the normal male dandy of the period (for example, Manet), Bazille cultivated his appearance in such a way as to make it a site of almost feminine regard. Given the fact that he was exceptionally tall, he was pre-targeted for the curious gaze, and it appears that he used dress to amplify the way he stood out rather than to normalize it. Exactly how he stood out and how his dress intensified the effect can be seen in Henri Fantin-Latour's group-portrait tribute to Manet entitled *Studio in the Batignolles* (fig. 30) of 1870. Bazille dominates the right side of the large painting, both through his physical stature and, perhaps even more significantly, through his Scots plaid trousers. Although this may not lead to the conclusion

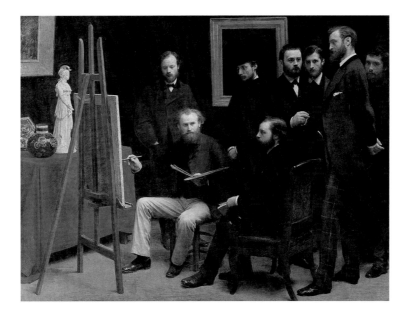

Fig. 30. Henri Fantin-Latour
Studio in the Batignolles, 1870
Oil on canvas, 80⅜ × 107⅝
inches (204 × 273.5 cm)
Musée d'Orsay, Paris

that dress was a conscious project of self-feminization, the signals Bazille flashed by his dress would certainly have produced spectator responses that he must have recognized as being somewhat gender uncertain. Had he not enjoyed the responses, he would likely have lost the taste for dressing. He never did, not even in the army in 1870.[13]

Bazille's dress is the most prominent sign of his partial self-feminizing (never to the point of what would likely have been regarded as effeminacy), but it is not the only one. His passion for (beyond simple interest in) concert music, while never an absolutely fixed gender sign in the period, would have quite likely appeared more feminine than masculine, and his privately indulged technical prowess as a pianist would certainly have seemed even more so.[14]

"Amateur pianist" is virtually absolute in its female gendering in this period.[15] During the last three years of his life, Bazille spent an ever-increasing number of his evenings with the man who seems to have been his closest friend, the music scholar Edmond Maître. Together they played piano four-hand scores of classical composers and then, following Maître's developing taste, modern German repertoire, including Wagner.[16] As piano four-hand playing is the most intimate of musical activities (in an actual physical sense), it is difficult not to suggest that sexual excitement, if only in sublimated form, marked the musical activity of the Bazille-Maître duet. Two feminized men were playing (music) together every night. Bazille pictures this routinely in his letters to his parents and likely pictured it verbally to all his Parisian acquaintances as well.

Besides the routine of making music with Maître, Bazille's concert-going schedule becomes ever busier as the decade passes. He apologizes to his parents for indulgences in expensive concert series.[17] Then, in early 1870 came his grandest musical plan (one seemingly facilitated by Maître). He obtained tickets to see Wagner's *Lohengrin* staged in Brussels with the composer in attendance.[18] In addition, he had an invitation to a banquet in Wagner's honor after the performance. Much to his chagrin, the performance was canceled, so he never met the veritable god of the modern music of his generation, but it is significant that he tried as he did. Twelve years later Renoir would succeed where Bazille had not. He met Wagner and painted his portrait.

Looking into the Studios

If one accepts the notion that Bazille's highly visible passion for music would likely have been perceived as self-feminizing (something that finds ample confirmation in Emile Zola's novel *L'oeuvre,* written in the 1880s but based on the lives of his artist friends, Bazille included, in the 1860s), it is tempting to look for larger behavioral patterns supplementing dress and a publicly displayed music passion to round out the picture.[19] I would argue that Bazille's never-ending concern with his studio offers an important subtext to the pattern of self-feminization. Bazille assembled three studios over the decade, each more ample and comfortable than the previous. They were more than places of work; he lived in them and often shared them as necessary with Monet and Renoir. Sometimes rent was shared, but never very dependably. It's probably not much of an exaggeration to suggest that Bazille kept house for his friends, probably willingly at times and not so willingly at others. In any event, Bazille's painter friends seem to have felt welcome—Monet in particular, since the walls of

Fig. 31. Frédéric Bazille
Studio in the rue La Condamine,
1870
Oil on canvas, 38⅛ ×
50 inches (97 × 127 cm)
Musée d'Orsay, Paris

Bazille's first two studios were decorated with groupings of his own paintings interspersed with those of Monet. This situation is amply documented in the paintings Bazille made of his studios and additionally in Renoir's important *Bazille at His Easel* from 1867 (fig. 21, which Manet bought), where the space of the studio behind Bazille is dominated by a recent Monet snowscape.

Significantly, Bazille's painting of his final studio (which was a large and lavish space by studio standards of the day) shows it decorated somewhat more by his own paintings from 1868 and 1869 (fig. 31). The whole space, which Bazille carefully redecorated with Renoir's help before moving in, is presented as a place where he can receive Manet and the critic Zacharie Astruc (to look at Bazille's recent work) and house more informally his friends Monet, Renoir, and Maître, who is, not surprisingly, shown seated at—and presumably playing—the piano.[20] The figure of Bazille standing with his back to the viewer was added by Manet in order to represent the studio's primary inhabitant—something Bazille had chosen, for whatever reason, to omit.[21] Probably seeing himself as painter-host, introducing the spectator into the fictive space of his painting (and studio), Bazille felt it inappropriate to inhabit the space. After all, that space already represented him completely, so his actual presence was, from a documentary realist perspective, redundant. Bazille's last painting of his studio is different from the two earlier ones (cats. 7 and 14) in several important respects. To begin with, figures are represented and plotted in such a way as to establish a neatly closed narrative. The painting is, in other words, conceived as a genre piece that is "absorptive," or thoroughly self-contained and seemingly oblivious to an outside spectator (to use the term devised and elaborated by Michael Fried to distinguish pictorial narrative that fictively excludes the spectator from "theatrical" pictorial narrative that confronts and thereby includes the spectator).[22] Being absorptive, Bazille's painting is intended to be readable as internally coherent with regard to situations portrayed. It succeeds in this by providing clearly pictured clues as to what every figure is doing in the studio.

Either they are *looking* (at Bazille's painting on an easel), or they are *listening* to Maître play the piano. Bazille is represented as responsible for everything being seen and Maître for everything being heard. Bazille and Maître are pictured as constructing an ambience of absolute visual and auditory refinement worthy of the sensibilities of the figures represented, all of whom are male.

Bazille's studio is a seemingly self-sufficient man's world—a domestic and professional site where men provide everything for themselves. Women's presence, seen in those things conventionally tied to women—the decoration of an interior and the domestic performance of piano music—is pictured as unnecessary by not being pictured at all, except in two paintings of bathers by Renoir and Bazille. Interestingly though, nobody seems to be looking at these paintings, which seem part of the décor Bazille elaborated with his painting on the left wall of a nude male, *Fisherman Casting a Net* (fig. 32). The visual subtext of the paintings on the wall might be understood as signaling Bazille as a realist rather than academic purveyor of both male and female visual attraction. His artistic gaze appears coded either as un-gendered or bi-gendered (or universal) in its represented form. Renoir, on the other hand, is coded (by his one painting of a female nude) as more conventionally just male (or *just* heterosexual of gaze).

At the time Bazille painted his last studio, only one artist of the realist avant-garde could have anticipated his entrepreneurial male mastery of the sexually universal realist gaze. That artist was Manet, who between 1862 and 1865 had produced a group of works that alternated in focus between female and male nudity. He began with *Luncheon on the Grass* of 1862 (fig. 19) and *Olympia* of 1863 (fig. 33), both of which present alarmingly confrontational images of nude women staring out at the spectator from overtly sexual pictorial situations. Then in 1864 and 1865 Manet presented the male nude in sensuous, unconventional images of *The Dead Christ with Angels* (fig. 34) and *Christ Mocked* (fig. 35). While not as sexually straightforward as the previous female nudes,

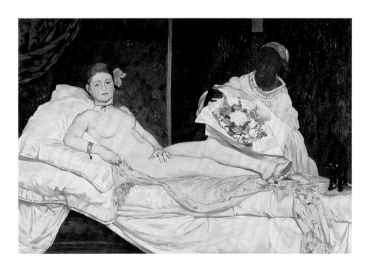

Fig. 34. Edouard Manet
The Dead Christ with Angels,
1864
Oil on canvas, 70⅝ ×
59 inches (179.4 × 149.9 cm)
The Metropolitan Museum
of Art, New York; H. O.
Havemeyer Collection,
Bequest of
Mrs. H. O. Havemeyer

Fig. 35. Edouard Manet
Christ Mocked, 1865
Oil on canvas, 75 × 58⅜
inches (190.3 × 148.3 cm)
The Art Institute of Chicago;
Gift of James Deering

Manet's male nudes are embedded with a powerful aura of necrophilia and sadomasochism. By 1869 Manet could well be regarded as the established pioneer in presenting modern realist nudity *as sexuality,* and with such unguided notions of who (male or female) looked with sexual interest at whom and why.

Manet's central presence in Bazille's studio seems ultimately to signal a good deal more than a simple gesture of respect from a realist artist of one generation to one of another. Nobody but Manet, positioned as viewing a picture within a picture, could so clearly and effectively have ignited Bazille's picture with so vigorous a thematization of male authority in the picturing of modern sexuality. Certainly Monet, who is somewhat uncomfortably present on the stairway to the left, where he seems both there and almost unwilling to be there, would not have functioned appropriately as the figure studying the picture on Bazille's easel. He had, for whatever reasons, no commerce whatsoever either in the pictorializing of the overtly sexual or in a cultural ambience perfumed with serious modern music. Monet's role in this picture is roughly comparable to that which he assumes in Fantin-Latour's *Studio in the Batignolles,* which was being executed at about the same time.[23] He is a sort of uncomfortable outsider in both paintings, and in both he is positioned as an antipode of Manet. For reasons that will be sketched later in this text, a kind of either/or polarity of artistic project had by 1869 become clear in the figures of Manet and Monet. They had come to represent competing extremes in the realist enterprise: the former persistently engaging in complexities of pictorial reference in matters of history, politics, sexuality, and religion; the latter representing more or less complete indifference to all matters lying outside what he perceived as the immediate day-to-day challenge of conjuring (by whatever technical means necessary) pictorial equivalents for his immediate sensations of visible nature. Seeming to think away feelings that were not purely visual, Monet would likely have abhorred the painting Manet is shown examining in Bazille's *Studio.* That painting being examined is Bazille's *Summer Scene* (fig. 36), which would eventually appear in the Salon of 1870.

What kind of picture is *Summer Scene?* It is a rather different painting when seen alone than in the pictured context of Bazille's studio, where it is shown as part of a group of related paintings by Bazille and Renoir—a group with which

Fig. 36. Frédéric Bazille
Summer Scene, 1869
Oil on canvas, 63⅜ ×
63⅜ inches (161 × 161 cm)
Fogg Art Museum, Harvard
University Art Museums;
Gift of Mr. and Mrs. F.
Meynier de Salinelles

it presumably converses in ways understandable to a knowing visitor. Simply put, the painting is of a group of eight seminude men positioned around a swimming hole or beyond it. Figures swim, wrestle, remove their clothes, or just stand around, but whatever they are doing physically, all are gazing and being gazed at in one way or another. A drawing for the painting shows some figures fully nude, but the final painting adjusts this with a variety of prominent bathing trunks. The painting, whatever its idyllic pretense, is a highly contrived construct featuring, more than anything else, relentless same-sex gazing. The focus of the gazing is the nude male body, just as the focus (again same-sex) is on a nude female body in both of the two large paintings by Bazille and Renoir on the studio's rear wall. And it is Manet who is brought into the studio, presumably to comment on what he sees—to act, as it were, as the knowledgeable male regarder of male regard. Then, as we have noted, Manet has added a portrait of Bazille posed by the easel, as if waiting for a verbal response from Manet offering his reading of the work.

And how was the painting to be read? Certainly it is, on one level at least, a tribute to Manet, in particular to his epochal *Luncheon on the Grass* (or *Bathing*) (fig. 19), which when shown in the Salon of works rejected from the official Salon of 1863 was widely perceived as the most radical of modern works. But more than just being a tribute, Bazille's *Summer Scene* stands as a kind of clarifier and extension of Manet's painting. It depicts bathing *as bathing* rather than as a historically conceived combination of references to earlier art and to advanced

realist practice. Bazille further clarifies the image by detaching it from the spectator's presence, and again, as in his last painting of his studio, he makes it completely absorptive and completely a genre painting. Yet as he does this, he complicates the genre activity itself by emphasizing same-sex regard throughout the picture. In a certain sense, he worked more as a true realist than Manet had, but the bit of reality isolated was as provocative sexually as Manet's had been. By not having any of his figures address the spectator directly, Bazille replaces the spectator's required complicity with a more voyeuristic form of access (the spectator chooses to look, rather than being compelled). The result is strangely closer to the presentational strategies of contemporary academic artists like Gérôme and, more to the point, those of Bazille's teacher, Gleyre.

The absorptive and resolved genre aspect of *Summer Scene*, its comparatively high degree of technical finish, and its elaborately posed nude figures point equally to contemporary academic practice, even in the way that technical finish is managed without much attention to eye-catching detail. Very little in the way of loose, spontaneous brushwork appears, and the lighting of the picture has a smoothness and uniformity that are quite remarkable in a realist painting. Again, academic work, particularly Gleyre's, is recalled. The subject, too, with its strongly sexual subtext, recalls the eroticism, often approaching pornography, characteristic of genre treatments of the nude in academic work, particularly after 1863. The difference, and it is significant, is that Bazille's nudes are male. As a representation of homosexuality (male or female), Bazille's is less overtly developed than precedents for such in the work of Courbet during the mid- and late 1860s, but the heterosexual stance of Courbet in his paintings of lesbians is unqualified in its confidence and in the nature of its curiosity.[24] By comparison, Bazille's stance seems decidedly homosexual, even though this term was far from being clearly defined when the picture was painted.

As the painting within the painting of Bazille's last studio, *Summer Scene* can be seen to amplify rather considerably the former painting's project, turning what had appeared just a man's world of cultural professionals into a man's world of an even more comprehensive sort, a sort where, in the fictive sun of the south of France, male sexuality (as it involves other men) is presented as flourishing naturally in the seeming everydayness of the swimming hole. How much the *Summer Scene* presaged directly the fascination of the contemporary American painters Thomas Eakins (with swimming holes) and John Singer Sargent (with workers of various sorts) is impossible to say, but there seems something very timely about Bazille's performance, whether he or any of his friends precisely realized it or not.[25]

Monet-Bazille and "Timeliness"

As a theoretical notion, "timeliness" serves perhaps better than anything else to facilitate a transition in the discussion of Monet and Bazille from the domain of personal relationship and psychology to that of comparative painting practice. In certain basic ways, patterns of codependence *and* difference already suggested can be seen to continue from one domain to the other, but a host of other art-political and art-theoretical issues come into play when attention shifts from everyday behavior to the intentionally durable production of paintings. The reason timeliness is being introduced here to identify the issues involved in

production (and anticipated reception) is that the term appropriately suggests the considerable uncertainty that obtained in the 1860s with regard to what kind of image or images might best represent (or express) the unique time and place of painting. Timeliness, like alternative (if by now overconflicted) terms such as modernity or modernism, implies a driving concern for locating painting in the present rather than the past, and in the here rather than the there.

Deriving initially from the critic Charles Baudelaire's insistence that painting celebrate the heroism of modern life—that it be distinctly of its time—a near-obsession with timeliness took many different forms in the realist (as well as the academic) practice of painting in the 1860s.[26] No firm consensus developed as to what timeliness might definitely look like, and the persistently vexing absence of consensus permeates both the painting of the period and the intellectually strenuous criticism of that painting, voiced by a wide range of commentators representing an equally wide range of ideological perspectives.[27] Did the timely absorb history or reject it? This question remained basic throughout the decade, and in their respective painting practices, Monet and Bazille wrestled with it. Issues of agreement and of disagreement are visible at every point, becoming most pronounced at the decade's end.

In order to understand where the two artists situated themselves as regards the issue of timeliness, the paintings, rather than anything the artists are recorded as having said about them, move to the fore as the most consistently reliable index. Precisely how each artist presents the timely is permanently visible in the surviving paintings and in the record of some that have not survived. What the paintings show very prominently is how the two artists installed strategies of timeliness early on and how these strategies were more capable of intersection at some times than at others. But at base the strategies were different in their founding operations—different in the way the painted moment was intuited and enacted pictorially.

For Monet, the moment was conceived (at least as he painted it) as being perceptually immediate, involving no memory, or feigning to have none. Having developed as a young artist in the company of landscape painters like Eugène Boudin and Johan-Barthold Jongkind, both of whom cultivated a rapid and somewhat cursory technique to convey a sense of their painting's virtual oneness with a seemingly precise moment of vision, Monet was inclined to devise images that continued this precedent. He did this not simply by adopting the methods of Boudin and Jongkind wholesale but rather by seeking constantly to find more concise and direct ways to construct moments—ways that would make the moments seem increasingly like instants.

Monet's paintings from 1864 to 1865 from the coastal towns of Honfleur and Sainte-Adresse in Normandy, near his home in Le Havre, show first an abruptness of shape and broad color accent that serve more than anything else to speed up the visual delivery of the moment from painting to spectator. When the particular prospect of a seascape is complex in its features, as in *The Headland of the Hève at Low Tide* (cat. 5), Monet devises his view so as to present that complexity (of texture and tone) through a nervous web of dots and dabs that rattle visually at persistently "high speed" within clearly divided zones of beach, water, and coastal cliffs. His palette is dense in its range of tones, but that density is hyperactive, with ceaseless small contrasts, rather than calmly moody. The light effect constructed is, it seems, intended to be unfamiliar yet rapidly

graspable visually. It has the appearance of never having been painted, perhaps never having been seen (or even having existed) visually before Monet discovered and delivered it in paint.

Monet's strategy of presenting "findings" rather than "makings," to use Richard Shiff's terms, is here powerfully in place in the service of offering up a pictured moment that pretends to have no past, either experientially or in its representation.[28] Working with Monet in the summer of 1864, even at times virtually copying his work, Bazille traces as best he can Monet's mode. His *Beach at Sainte-Adresse* (cat. 1) simply would not have happened without Monet's *Seaside at Sainte-Adresse* (cat. 2) and other paintings like it. Monet's work and Manet's (including his seascapes), which Bazille first saw in 1864, seem together to have introduced him to a sense of timeliness, which until he had viewed more of Manet's work in the Salon of 1865 (where *Olympia* and *Christ Mocked* appeared) probably was weighted in the direction of Monet's privileging of the instant of vision.

The type of momentum apparent in Manet's work that was sustained by the paintings shown in the 1865 Salon was different from that experienced by

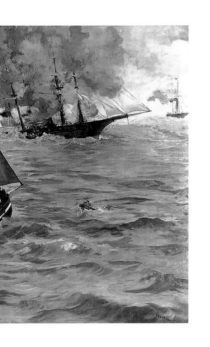

Monet and Bazille the previous year, when Manet's large seascape *The Battle of the Alabama and the Kearsarge* (fig. 37) had dominated a private exhibition at the "Gallery" Cadart. That painting seems to project an instant of vision in terms that could have been seen to run parallel with Monet, despite the ambiguous political overtones embedded in the image of two American battleships fighting it out in French waters during the Civil War. Manet's 1865 Salon paintings, on the other hand, brought forward from 1863 the complex web of art historical or art traditional associations that had emerged in *Luncheon on the Grass,* where prototype images from Titian, Raphael, and Watteau were invoked with various degrees of directness. That painting and the new ones of 1865 gave a far less simple representation of timeliness—one that seemed to insist that the moment, as experienced and as capable of being pictured, is far more complex than the instant. Timeliness seems necessarily to involve memory and passions continuous with memory as well as immediate sensation. Could painting be timely without its own memory functioning? This was, at least in part, what Manet's figure paintings asked.

And of course this question was not asked in a void. As scholars, often working from very different perspectives on the 1860s, have begun to emphasize, history and particularly art history are subjects of major interest for the decade where, for the first time, quite different discursive frames are made to surround accounts of the historical relationship between art and the society contemporary with it. The art historical disputes of the decade were not quiet ones emerging from limited-circulation academic books. Rather, they were very public and focused around two of the premier theoretical voices of the period—voices whose audience was, at least in the circle of the arts, very broad. On the one side was Charles Blanc, a powerful figure in the French fine arts administration, founder in the late 1850s of the *Gazette des Beaux-Arts,* and writer in the 1860s of both a grammar of the fine arts and an elaborated multivolume history of

them.[29] On the other side was Hippolyte Taine, the controversial author of *History of English Literature* in the mid-1850s and an emerging sociologist of art who was appointed in 1864 to lecture on the history of art on a recurrent basis at the Ecole des Beaux-Arts, the French national art school.[30] Taine's lectures on Greek, seventeenth-century Dutch, and Italian art were published almost as soon as they were delivered, and they were immediately translated into other major European languages.

While neither Blanc nor Taine was directly sympathetic to the art of their own time, both provided via their histories certain notions that were intended to affect contemporary production. Both discussed something they called the "ideal," but they defined it very differently. For Blanc the ideal was transhistorical and never bound to the mundane realities of a particular time or place. It appeared in practice most powerfully in High Renaissance Italy, especially in the work of Raphael. Having appeared, it remained to be emulated or variously aspired to by any and all artists truly concerned with elevating the spectator rather than leaving him or her to wallow in the routine squalor of real life. Obviously, Blanc was very much in tune with the standards and practices of the Ecole des Beaux-Arts, where great historical painting in the manner of established classical masters (Raphael preeminent among them) was considered ideal practice.

Taine conceived of the ideal as absolutely localized, with healthy civilizations at specific times and places producing distinctive manifestations of the ideal, which were highly inflected by what Taine called their "milieu." For Taine this term was understood as the particular combination of climate, race, and social moment under which works of art were produced. Ideal works were those which, through the intentions and practices of the most powerful talents, absorbed and delivered the essential pulse of the milieu. The most important implication of Taine's notion of the ideal—important at least for contemporary artists working in the 1860s—was that no style was prescribed as absolute. Indeed, style was positively relative, and when ideal style emerged it was seen to appear in every significant artistic manifestation, whether a conventionally finished product or simply a sketch. In fact, Taine was perfectly willing to imagine the sketch as more revealing, or more directly revealing, than a finished work.

As regards subject matter, Taine was equally relativist in his preferences. Certain types of subjects emerged from particular milieus more naturally than others. He saw his own milieu more aligned with seventeenth-century Holland than with any other time or place, so he cited landscape painting, genre painting, and portraiture as the strongest candidates for subjects to support contemporary practice. Unlike Blanc's, Taine's ideology of art history gave no obvious support to the standards and practices of the Ecole des Beaux-Arts.

Not surprisingly, the differences between Blanc's and Taine's constructions of art history and their implications for contemporary art resonate very strongly in the art criticism of the 1860s as well as in artistic practice. The debate contained in Blanc's and Taine's writings was liberating in the sense that such clear conceptual *and* procedural alternatives emerged—alternatives that required being sorted by anyone seriously interested in the practice or the appreciation of the arts. Those with radical inclinations—the realists—obviously took heart from Taine. The more traditional figures were similarly secured by Blanc's writings.[31] But what about those who perceived wisdom in both camps?

Edouard Manet's elaborate negotiations with historical art, via direct and indirect quotation, have been the subject of much scholarly writing, as has his counter-project of generating realist immediacy.[32] Manet has been seen to have constituted his art as something thoroughly possessed of a deep (and ideal) sense of historical Frenchness while at the same time grounded in pictorial strategies and sensitivities of the high-saturation spectacle of 1860 Paris.[33] In a similar, if less nuanced, way Renoir's early work has been characterized as seeking to situate itself within history *and* the present.

But what about Monet and Bazille? We have already described Monet's virtually absolute pictorial commitment to representing the instant of sensation, and we have seen Bazille influenced by that commitment, even while working happily in Gleyre's studio as a student following standard academic routine. And we have suggested the importance to both artists of Manet's sustained production of figure paintings, which were timely in spite of, and partly because of, their technically and historically complex maneuverings—maneuverings that contained gestures of historical self-awareness delivered via wildly abrupt "facings" *at* the spectator. Both Monet and Bazille would spend the remainder of the decade processing their response to circa-1865 Manet and, in the case of Bazille, often reprocessing Monet's processing.

As suggested earlier, Monet's pictorial behavior, beginning after the 1865 Salon, seems driven by a nearly single-minded desire to simplify and to naturalize Manet's accomplishment and to relieve it, so to speak, of its historical baggage. The project was to embed it more securely in a milieu conceived of as a more literally real moment. The decision to begin rephrasing Manet facilitated as well Monet's virtually mandatory move into monumental figure painting, which he hoped would identify him as a major young artist, so the significance of the decision both ideologically and to his reputation was considerable. And the immensity of the task was certainly increased by the magnitude of the stakes involved.

In the summer of 1865 in the forest of Fontainebleau, Monet undertook to produce an enormous *Luncheon on the Grass* of his own —one developed on the spot with life-size figures posed in a plausible picnic grouping. Monet would not finish the painting, which today exists only in fragments, but *The Strollers* (fig. 38, cat. 9), a medium-sized study (posed by Bazille with Monet's mistress, Camille), demonstrates how confidently—at least at first—Monet proceeded. This study is exceptionally bold in its graphic and coloristic abbreviations, which were intended to sustain a sense of natural outdoor light. It seems to follow effortlessly along the technical lines developed in Monet's landscape practice, but presenting figures as it does, it looks far more like a sketch than like a model to be enlarged. The chief difficulty Monet experienced with the project was that of enlargement. Abbreviations that work in the study come apart visually in the fragments of the larger canvas. They are controllable only in a small-scale version of the painting (fig. 39) that constitutes the project's clearest visual record.[34]

While Monet worked on the project, with Bazille posing for him, he injured his leg, and that accident produced Bazille's first (indeed accidental) engagement with the Monet-Manet "conversation." Just as Monet was undertaking to naturalize Manet, Bazille found an opportunity to join the project with a

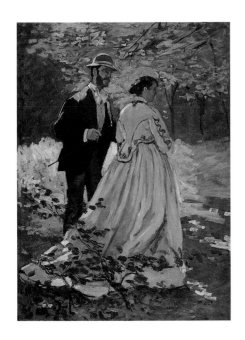

Fig. 38. Claude Monet
The Strollers, 1865
Oil on canvas, 36⅝ × 27⅛ inches (93 × 68.9 cm)
National Gallery of Art, Washington, D.C.; Ailsa Mellon Bruce Collection
(see page 38)

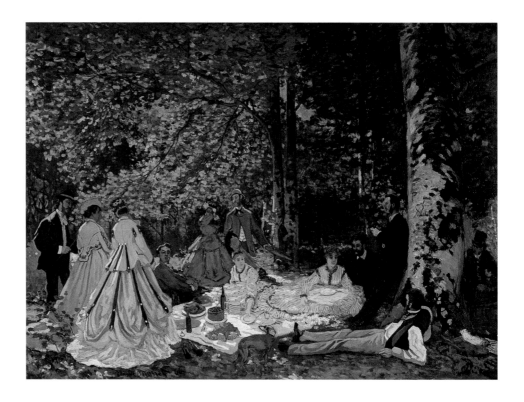

footnote of his own. Having rigged a water-dripping device over the injured leg of Monet, who was bedridden in his hotel room, Bazille had time on his hands, which he used to produce a small painting of Monet in his lamed condition. *The Improvised Field Hospital* (fig. 40) is an unassuming picture but an important one in elaborating the shared interests of the moment. Monet resting in his bed was a ready-made genre subject and a portrait subject as well. His condition and the way that condition appeared to Bazille likely evoked memories of Manet's two paintings from the Salon of 1865: *Olympia* and *Christ Mocked.* Monet was not, of course, a prostitute "receiving," nor was he being tortured, but his situation seems to have suggested both to Bazille as he took up a painting position across

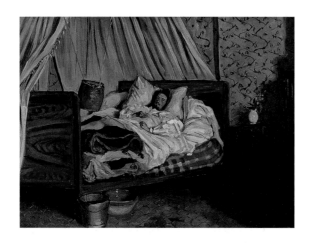

the room from Monet's bed and crafted an apparently unposed (it was in fact pre-posed) image that alternates between smooth and animated areas of paint so as to record and enliven the representation in roughly equal measure. To stretch this image in the direction of genre, making it a representation of the painter and his model, Bazille introduced a shadow of himself at the picture's right edge. Something of the sense of a moment stretched by the duration of a contemporary photographic exposure pervades the image. This will prove an important sense to be cultivated in Bazille's subsequent work, even though it begins from a specific (and real) situation in *The Improvised Field Hospital.*[35]

Representative of other work they produced during the summer of 1865 are Bazille's *Landscape at Chailly* (cat. 12) and Monet's *Bodmer Oak* (cat. 11). Monet's painting exercises the same sort of graphic and coloristic abbreviations that characterize his *Luncheon* project, while Bazille works with a more traditional palette, but one animated by a considerable degree of crispness in the shifts between light and dark tones, and between detail and generalization in

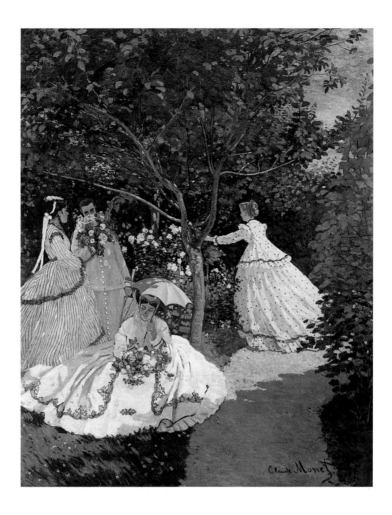

brushwork. As we have noted, the same characteristics mark *The Improvised Field Hospital* as well.

In the years that follow, Bazille's work shows a tendency to separate the technical inclinations of looseness and finish, which he combined in 1865. Only informal works—works describable as sketches—continue to cultivate a sense of improvisatory immediacy. The *Self-Portrait* of 1867–68 (cat. 18) demonstrates this tendency. Otherwise, as if to satisfy craft demands of the various Salon juries, Bazille works to suppress anything resembling spontaneity of pictorial treatment. He is not alone in this. Monet, too, produces his most tightly finished work in 1866, especially in *Women in the Garden* (fig. 41), which was rejected by the Salon of 1867. Bazille seems to have admired this painting very much and purchased it from Monet, paying for it in monthly installments.[36]

What likely impressed Bazille was Monet's success in producing a large figure composition where the informality, seemingly unposed, of a visual instant was conveyed through a brisk yet finished consistency of drawing and painting that sustained a sense of even sunlight throughout. There is even a suggestion of action, stopped in the manner of later snapshot photographs, in the woman seen moving behind the central tree from the painting's right side. Monet has managed to build a sense of the instant from his collective poses and their seemingly accidental, or momentary, character, all held by what appears to be a singular moment of light. The painting was executed outdoors, without any significant preparatory sketches, and the result is remarkably unified in all its representational components. The persistent lightness of Monet's palette, which emphasizes clear areas of color and only slightly less clear areas of shadow, is

18. Frédéric Bazille

Self-Portrait, 1867–68

Oil on canvas, 21½ × 18¼ inches (54.6 × 46.4 cm)
The Minneapolis Institute of Arts; The John R.
Van Derlip Fund

Fig. 42. Gustave Courbet
Bathers, 1853
Oil on canvas, 89⅝ ×
76 inches (227 × 193 cm)
Musée Fabre,
Montpellier, France

Fig. 43. Gustave Courbet
*The Meeting (Bonjour
Monsieur Courbet)*, 1854
Oil on canvas, 50¾ ×
58⅝ inches (129 × 149 cm)
Musée Fabre,
Montpellier, France

somewhat unexpected in a large-scale figure painting. Monet's confidence to manage this palette and to combine it with the apparent randomness of poses, to treat his composition as a sort of decorative extension of the central tree, and to keep figures equally distant (or nearly so) from the spectator, both visually and psychologically—all of this produces an image that is at once radically simpler than anything Manet had conceived and radically asssured in its representation of an instant of vision. One suspects that a good deal of this confidence came from Monet's increasingly serious study of Japanese woodblock prints and from a sort of imagined combination of their informal decorative presentation of immediacy, or randomness of pose, with the emphatic black-and-white stillness of contemporary photography.

Fig. 44. Claude Monet
Luncheon (Interior), 1868–69
Oil on canvas, 90½ ×
59 inches (230 × 150 cm)
Städelsches Kunstinstitut,
Frankfurt

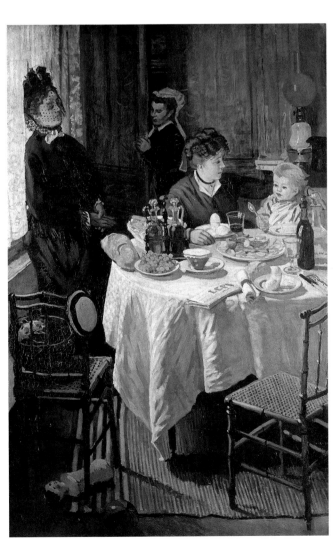

Monet never painted another picture like *Women in the Garden,* but Bazille definitely did. Virtually all of his figure paintings, and to a degree his landscapes as well, seem in various ways to issue from Monet's prototype, acting in loose and often uneasy conversation with other paintings Bazille knew well from the collection of Alfred Bruyas in Montpellier, especially two works by Courbet: *Bathers* from 1853 (fig. 42) and *The Meeting (Bonjour Monsieur Courbet)* from the following year (fig. 43). The presence of Courbet (along with Jean-François Millet) as a highly active force in French painting in the 1860s is usually underplayed in scholarly accounts dedicated to tracking historical supercession and in which Manet's art is seen effectively to have displaced from active currency the seemingly less urbane and timely realism of Courbet.[37] But judging from their paintings, Monet and Bazille were attracted to certain aspects of Courbet's work as they simultaneously processed Manet's after 1865. In his figure paintings *Women in the Garden* and later *Luncheon (Interior)* of 1868–69 (fig. 44), Monet was clearly more comfortable with the kind of instant constructed by Courbet

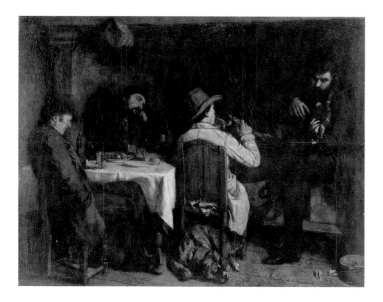

in paintings like *After Dinner at Ornans* (fig. 45) and *The Stonebreakers* (fig. 46), where groupings appear found by a momentary glance rather than engaged by the spectator as in Manet's works. Monet clearly responded to Courbet's "instant" groupings, as he did to the persistently worked and physically animated character of Courbet's seascapes of the mid- and late 1860s, such as *Beach Scene with a Boat,* ca. 1869 (cat. 19), in which the offering of finished sketch as finished painting—so basic to the Impressionist project of the early 1870s—makes its first appearance. As noted earlier, Monet and Courbet seem to have remained in personal touch during the late 1860s. Courbet was the witness to Monet's marriage, and Monet felt sufficiently close to Courbet to visit him in jail after his conviction for damages to the Vendôme Column in Paris, said to have been authorized by him under the short-lived Commune of 1870–71.

Bazille was less close to Courbet but was, figuratively speaking, surrounded by him in Montpellier. Bruyas was the most enthusiastic collector of Courbet's painting, so it is with Monet's *Women in the Garden* in his personal possession and with Bruyas's Courbets close at hand that one must imagine Bazille working during the last years of his life. Those years saw the completion of, among other things, his last studio and *Summer Scene,* the monumental *Family Gathering* of 1867–68 (fig. 47), and, arguably his masterpiece, *View of the Village* of 1868 (cat. 20). *Family Gathering,* certainly one of Bazille's most experimental works, presents virtually his entire family (himself included) gathered on the terrace of their summer house outside Montpellier. With the exception of his father, who appears partly in profile, all eleven figures face outward, confronting the spectator with an array of portraits seemingly engaged in nothing more than posing for the painting. Neither the trees overhead nor the still life and sunspots in the right foreground relieve the sense that the picture is about posing for portraits.

Drawings made for the painting show a more conversational interaction between the figures, suggestive of Monet's studies for his *Luncheon on the Grass* two years before. These gestures toward a genre-like conception are totally abandoned in the final painting, however, which Bazille painted in an entirely honest or natural way.[38] He lets the painting be thoroughly factual about itself and gestures in the direction of the contemporary group photograph as a way of representing an instant of a very particular sort—a posed instant.[39] Manet had

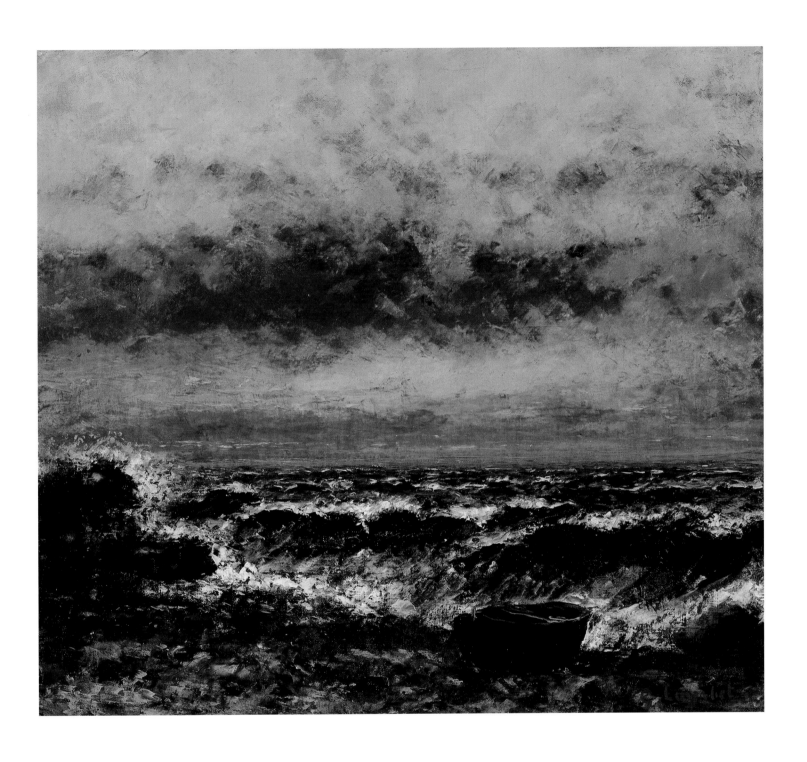

19. Gustave Courbet

Beach Scene with a Boat, ca. 1869

Oil on canvas, 18¾ × 21¼ inches (47.6 × 54 cm)
Private Collection

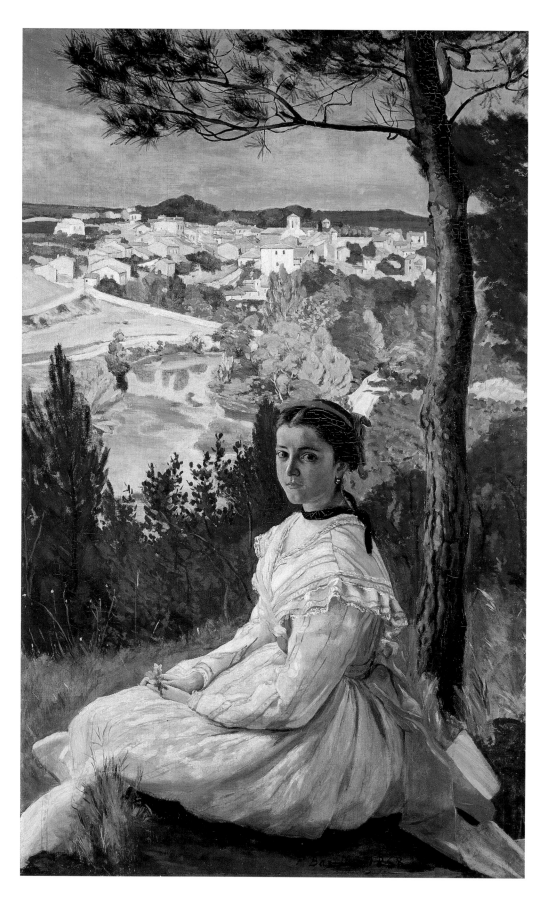

20. Frédéric Bazille

View of the Village, 1868

Oil on canvas, 51⅛ × 35 inches (130 × 89 cm)
Musée Fabre, Montpellier, France

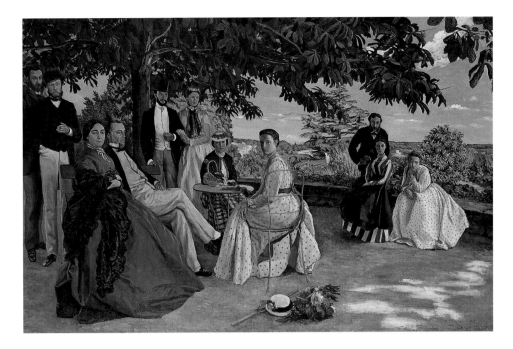

Fig. 47. Frédéric Bazille
Family Gathering, 1867–68
Oil on canvas, 59⅞ ×
89⅜ inches (152 × 227 cm)
Musée d'Orsay, Paris

done something similar in his *Music in the Tuileries Garden* of 1862 (fig. 48), as had Courbet in *The Meeting (Bonjour Monsieur Courbet),* but Manet's poses seem accidental compared to Bazille's, and Courbet's, while portrait-like, imply a narrative connection between the figures. Bazille refuses to permit his painting to be read as a genre painting. No connective fictions intrude, and the effect on the spectator remains disarming to this day. At a time when portraiture was being encouraged as a most appropriate modern subject by the critic Zacharie Astruc, who was close to Manet, Courbet, and the younger painters, Bazille employed insistent portraiture to deliver his most original conception of timeliness.[40] His painting as a presentation of grouped figures is so inverted from Monet's *Women in the Garden* that it is difficult not to see *Family Gathering* as a profoundly considered alternative, one where pictorial instantaneity subjugating figures as individual presences is countered by an all-revealing instantaneity of the moment of the portrait photograph.

 View of the Village continues the strategy of *Family Gathering* but applies it to a single-figure presentation and introduces an approximation of the continuous surface-unifying, and seemingly natural, outdoor lightness of Monet's *Women in the Garden*.[41] Besides the lightness, there is Bazille's stress on the decorative interconnection between the figure and the tree behind her. This functions much as Monet's tree to balance attention between the figure and the whole painting.

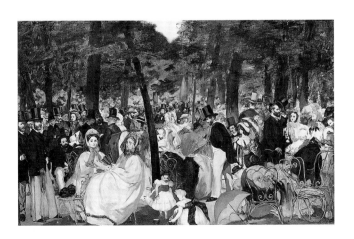

Fig. 48. Edouard Manet
*Music in the Tuileries
Garden,* 1862
Oil on canvas, 30 ×
46½ inches (76.2 × 118.1 cm)
National Gallery, London

The particular refinement of technique, the relaxed graphic and brushed finish that Monet developed, passes as well into *View of the Village*. All this brings the two painters more closely together than ever before around a particular painting, or at least around a painting that was not simply a copy or close variant. *View of the Village* figuratively absorbs Monet, while *Family Gathering* had done so through a strategy of more or less total inversion of Monet's example.

 For reasons that are not clear, Bazille's work takes a different turn in 1869. That turn produces

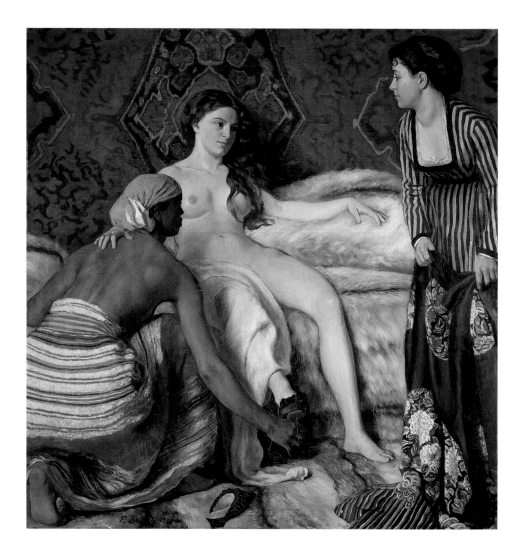

Fig. 49. Frédéric Bazille
La Toilette, 1870
Oil on canvas, 52 × 50 inches
(132 × 127 cm)
Musée Fabre,
Montpellier, France

paintings like the late *Studio* and *Summer Scene* and its pendant, featuring a much-gazed-at female nude, *La Toilette,* of early 1870 (fig. 49). Seen in the simplest terms, the late works are more traditional than previous efforts. Monet is virtually eliminated as a technical or conceptual model, as Bazille modifies the character of his realism with gestures toward the historically timeless as well as the timely. The timely, as we have seen, insinuates itself in terms of sexual fluidity built into his subjects. The timeless appears in the somewhat mythic feel that is grafted to the subject and held there with a new smoothness of pictorial finish that shows no trace of the unconsidered or improvised touch characteristic of both Monet and Manet. There is a strong recollection of the technical finish Courbet had developed in works of the mid-1850s, like the Bruyas *Bathers,* as Bazille seems to be seeking a sort of penultimate fusion between his painting and the prevailing standards of the Salon.

Bazille's late works, which from a technical and conceptual point of view suggest a sort of backtracking, should be seen against the backdrop of difficulties and overall loss of momentum and direction in Monet's work from mid-1867 through 1869. Monet had failed at making significant inroads at the Salon, even the comparatively liberal ones of 1867 through 1869. His last project undertaken with Salon success in mind was his *Luncheon (Interior)* of 1868–69 (fig. 44), which in typical form was devised as a "correction" of Manet's *Luncheon* (fig. 50), which had been done for the Salon of the same year.[42] Monet's effort produced a labored, almost compulsive, realist image. He presents a

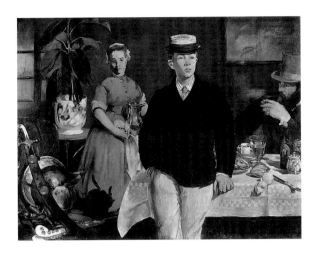

Fig. 50. Edouard Manet
Luncheon, 1868
Oil on canvas, 46½ × 60½
inches (118.3 × 153.9 cm)
Bayerische Staatsgemälde-
sammlungen, Munich

highly literal representation of lunch being eaten by his family and a visitor, complete with an empty chair for himself, which will fictively be occupied only when the painting is finished. But what appears as an instant of vision appears simultaneously as a painting that, given its technical elaborateness, obviously took a long time to paint. The conflicting double signal, in which viewing time and painting time contradict one another, ultimately dooms the painting as a coherent realist production. The painting was rejected by the Salon of 1870, which convinced Monet, probably more effectively than any other single event, that henceforth his reputation and his market would have to be developed in an unofficial way, using private exhibitions, commercial galleries, and auctions whenever and wherever possible.

Bazille certainly knew as well as Monet did the risk the latter was taking. No alternative reputational and marketing route existed in any dependable form in 1869. By 1874 there would be one, but Bazille did not live to see it, even though, as we have noted, he involved himself in early and unsuccessful plans for an independent exhibition featuring Monet in 1867. The kind of work Monet might have shown, had the plans for an independent exhibition succeeded, would have been very different from his *Luncheon (Interior)* and even more different from Bazille's current production. The live pulse of Monet's work starting in 1867 had again come to be located almost exclusively in small and medium-sized landscape works. Paintings like *The Seine at Bennecourt* of 1868 (fig. 51) and Monet's several views of a riverside boating and swimming pavilion at La Grenouillère (fig. 52), which Renoir also painted, display a completely

Fig. 51. Claude Monet
The Seine at Bennecourt, 1868
Oil on canvas, 32 ×
39⅝ inches (81.5 × 100.7 cm)
The Art Institute of Chicago;
Mr. and Mrs. Potter Palmer
Collection

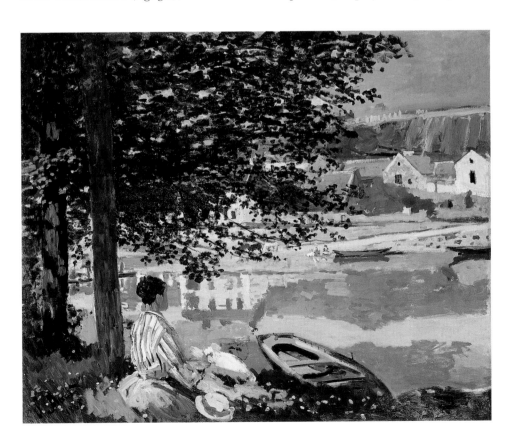

different Monet from the Monet of failed Salon figure paintings. The landscapes naturally contain figures as essential scenic components, but their presence does not in any way dictate the overall pictorial strategy. Figures are never subjects in these works. Rather, they are pieces, existing along with other pieces in a bold brushstroke-driven mosaic of unblended color that seems almost as rapidly devised as the scenes are viewed. Working to combine seamlessly impressions of unlimited improvisatory virtuosity with persistently upbeat, usually sun-filled leisure subjects, Monet was committing himself to a thoroughly new species of painting, which had only an imagined market ahead. He was taking every conceivable professional risk, behaving in a way that Bazille might have respected but had no intention of emulating. He would reserve his risks for the army.

In the meantime, Monet put the issue of 1860s figure painting to rest once and for all. Not content with simply having the figure absorbed into the landscape prospect and thereby neutralized as a presence, Monet set out in several paintings of 1869–70 to efface it. Seeming actively to hate the figure and the frustrations it had introduced to his painting, Monet forced it to yield, even when prominent in a painting, to the psychologically indifferent tendencies of his painted instants. He painted his wife in the winter seen through a large French window, where her appearance is naturally blurred both by distance and by a partly clouded stretch of glass. *The Red Cape (Camille in the Snow)* (fig. 53) brings forward the willful contentions of Monet's paint-handling to replace the new erasure of the figure as a counter-presence. Compared to the figure in Bazille's *View of the Village,* Monet's woman seen through a window appears, rather than posed, to be moving out of sight, getting out of the painting's way, so to speak. Monet continues his strategy of erasure or effacement in beach paintings done at the resort town of Trouville in Normandy. There the figure, or figures, seem turned into strokes of Monet's brush, rather than vice versa.

Fig. 52. Claude Monet
La Grenouillère, 1869
Oil on canvas, 29½ ×
39⅜ inches (75 × 100 cm)
The Metropolitan Museum
of Art, New York; H. O.
Havemeyer Collection,
Bequest of Mrs. H. O.
Havemeyer

Fig. 53. Claude Monet
The Red Cape (Camille in the Snow), 1868–70
Oil on canvas, 39 ×
31⅜ inches (99 × 79.8 cm)
The Cleveland Museum of
Art; Bequest of Leonard C.
Hanna, Jr.

The distance between Monet's bathing works from Trouville and Bazille's *Summer Scene* of bathers is immense, both ideologically and pictorially. Bazille is at his most thoughtfully retrospective as Monet emerges almost manically driven by a sense that realist painting is necessarily implicated in the flux of the moment. Timeliness, oppositionally conceived, continues variously to determine the projects of both artists without bringing their projects together, but without separating them absolutely.[43] Are the conclusions of circa 1870 expressible as being gendered in some fashion? Perhaps, but lacking further work by Bazille, such a conclusion is impossible to pursue.

Notes

In the course of preparing this essay, I have been generously assisted first by Judith E. Tolnick, director of galleries at the University of Rhode Island, who transcribed the manuscript and made exceptionally useful editorial suggestions. Anne Nellis, a graduate student at Brown University, provided skillful research assistance as necessary, and Michele Verduchi produced the first typescript.

1. Gaston Poulain, *Bazille et ses amis* (Paris: Renaissance du Livre, 1932).

2. The Bazille letters, those he wrote to his family and friends and those he received, have been re-edited, republished, and in part translated by several scholars. Letters authored by Bazille and translated into English were published in J. Patrice Marandel, ed., *Frédéric Bazille and Early Impressionism* (Chicago: Art Institute of Chicago, 1978). The letters were translated by Paula Prokopoff-Giannini. In the present text, letter references marked "P-G" refer to her translation. Didier Vatuone and Guy Barral produced a new French edition of the *Correspondence* (Montpellier: Presses du Languedoc, 1992). However, this edition was incomplete in its content. A complete (or complete to date) French edition of all the letters by and to Bazille appears in Michel Schulman, *Frédéric Bazille, 1841–1870: Catalogue raisonné* (Paris: Éditions de l'Amateur, 1995). In the present text, letter references marked "S" refer to this edition. Dianne W. Pitman has prepared a concordance of the various numbering sequences of the letters in appendix III of *Bazille: Purity, Pose, and Painting in the 1860s* (University Park: Pennsylvania State University Press, 1998). Besides being published as letters, the texts of many of them have figured strongly in John Rewald, *The History of Impressionism* (New York: Museum of Modern Art, 1961), and Kermit Swiler Champa, *Studies in Early Impressionism* (New Haven: Yale University Press, 1973). Catalogues for major exhibitions, such as Gary Tinterow and Henri Loyrette, *Origins of Impressionism* (New York: Metropolitan Museum of Art, 1994), and Aleth Jordan et al., *Frédéric Bazille: Prophet of Impressionism* (Brooklyn: Brooklyn Museum of Art; Montpellier: Musée Fabre, 1992), have also relied heavily on the letters for documentation.

3. P-G. 15, 20, 21, 31, 36, 38, 47, and 71. S. 12, 46, 51, 61, 74, 84, 195, and 227.

4. Champa, *Studies*, p. 84. S. 70, 82, 86, 92, 105, 108, 111, and 122.

5. S. 105–8, 111, 122, and 163.

6. P-G. 27, 43, 49, 52, 53, and 76. S. 93, 95, 115, 123, 126, and 162.

7. S. 189.

8. P-G. 62. S. 172, 174, 175, 177, 188, 202, 205, and 223.

9. Carolyn Dean, *Sexuality and Modern Western Culture* (New York: Twayne Publishers, 1996), pp. 1–17. Also, for basic discussion, see Michel Foucault, *The History of Sexuality*, vol. 1, trans. Robert Hurley (New York: Pantheon Books, 1978). I am also indebted to Anne Nellis, "The Shock of Paris: Paris, Pornography, and Paul Cézanne's Heterosexual Self-Construction" (master's thesis, Brown University, 1997). On Bazille's sexuality, see Pitman, *Bazille*, pp. 155–57.

10. P-G. 4–6, 8, 19, 25, 32, 41, and 80. S. 25, 26, 28, 32, 36, 37, 76, 101, and 260.

11. Gustave Courbet, *Letters of Gustave Courbet*, ed. and trans. Petra ten-Doesschate Chu (Chicago: University of Chicago Press, 1992), nos. 40-1, 40-2, 42-3, 45-2, 46-4, 48-3, and 49-8. See Michael Fried, *Courbet's Realism* (Chicago: University of Chicago Press, 1990) for a discussion of Courbet's "femininity," which proceeds from a theoretical perspective quite different from that proposed here for Bazille.

12. P-G. 18, 19, 24, and 73. S. 22, 26, 59, and 228.

13. P-G. 90, 93, and 98. S. 284, 292, and 298.

14. P-G. 8, 10, 23, 24, 31, 51, 62, and 69. S. 15, 36, 57, 59, 74, 97, 233, and 258.

15. Charlotte N. Eyerman, "The Composition of Femininity: The Significance of the 'Woman at the Piano' Motif in Nineteenth-Century French Culture from Daumier to Renoir" (Ph.D. diss., University of California at Berkeley, 1997). See also P-G. 53 and S. 123 for Bazille's description of a Salon painting, now lost, called *Woman at a Piano with a Young Man Listening*.

16. P-G. 60 and 71. S. 190 and 227.

17. P-G. 55. S. 151.

18. P-G. 80 and 84. S. 260 and 276.

19. See especially the character called Gagnière in Emile Zola, *L'oeuvre* (Paris: G. Charpentier, 1886).

20. P-G. 79. S. 210. On the identification of Astruc in this painting, see Pitman, *Bazille*, pp. 185–86.

21. P-G. 81. S. 263.

22. Michael Fried, *Absorption and Theatricality: Painting and the Beholder in the Age of Diderot* (Berkeley and Los Angeles: University of California Press, 1980)

23. Kermit Swiler Champa, "Concert Music: The Master Model for Radical Painting in France" (paper presented at the 16th International Congress of the International Musicological Society, London, August 1997; to be published in the collection of papers from this congress).

24. Sarah Faunce and Linda Nochlin, eds., *Courbet Reconsidered* (Brooklyn: Brooklyn Museum, 1988), p. 175 (catalogue entry written by Abigail Solomon-Godeau).

25. Michael Fried, *Realism, Writing, Disfiguration: On Thomas Eakins and Stephen Crane* (Chicago: University of Chicago Press, 1987), pp. 13–68. Trevor Fairbrother, *John Singer Sargent* (New York: Abrams, 1994), pp. 83, 135–36, and 141–45.

26. David Carrier, *High Art: Charles Baudelaire and the Origins of Modernist Painting* (University Park: Pennsylvania State University Press, 1996), pp. 1–78.

27. Michael Fried, *Manet's Modernism, or The Face of Painting in the 1860s* (Chicago: University of Chicago Press, 1996). See especially discussions of Zacharie Astruc throughout.

28. Richard Shiff, *Cézanne and the End of Impressionism: A Study of the Theory, Technique, and Critical Evaluation of Modern Art* (Chicago: University of Chicago Press, 1984), pp. 55–98.

29. Jane Mayo Roos, *Early Impressionism and the French State 1866–1874* (New York and Cambridge, England: Cambridge University Press, 1996), pp. 160–81. See also Fried, *Manet's Modernism*, p. 139.

30. Champa, *Studies*, pp. 72–73, discusses the relationship between Taine's lectures and the art criticism of Emile Zola. Mary Morton, a Ph.D. candidate at Brown University, is currently writing a dissertation on Taine's lectures from 1865 through 1869, based on both printed texts and the notes used for the lectures, which have only recently become available to scholars. Among other themes that she has uncovered is Taine's encouragement of the male nude as a subject meriting reconsideration. It is difficult not to attribute Bazille's confidence in this subject (as being an appropriate modern one) to Taine's promotion. The choice by the 1870 Salon jury of *Summer Scene* over Bazille's female nude, *La Toilette*, might also be seen to reflect Taine's influence.

31. Charles Blanc has received considerable attention in recent scholarship, particularly in Roos, *Early Impressionism*, and Fried, *Manet's Modernism*. Taine, on the other hand, has been less well served, even though the relationship between his lectures and the criticism of realists such as Astruc arguably demands serious attention.

32. Fried, *Manet's Modernism*, pp. 23–184.

33. T. J. Clark, *The Painting of Modern Life: Paris in the Art of Manet and His Followers* (New York: Alfred A. Knopf, 1985). For Bazille's description, see P-G. no. 58 and S. no. 19.

34. See Champa, *Studies*, pp. 1–12 for a sequential description of the *Luncheon on the Grass* project.

35. For a review of the discussion centering on the use or influence of group photography, see Tinterow and Loyrette, *Origins of Impressionism*, pp. 424–25.

36. Ibid.

37. Roos, *Early Impressionism*, argues persistently for the still-radical centrality of Courbet's work to the art politics of the mid- and late 1860s. Similarly Fried, *Manet's Modernism*, pp. 188–92, emphasizes the reinfatuation of realist critics with Millet's painting in the later 1860s. In terms of artists' ongoing interest in Courbet, one need point only to Paul Cézanne's work throughout the decade.

38. Schulman, *Frédéric Bazille*, p. 255.

39. See Pitman, *Bazille*, chapter 3.

40. For a discussion of Astruc's promotion of portraiture, see Fried, *Manet's Modernism*, pp. 233–35.

41. Berthe Morisot was particularly impressed by Bazille's accomplishment in this picture. See Dennis Rouart, ed., *Berthe Morisot—The Correspondence* (London: Moyer Bell Limited, 1987), p. 37.

42. For differing views of this painting, see Champa, *Studies*, pp. 27–29; Fried, *Manet's Modernism*, pp. 171–72; and Anne M. Wagner, "Why Monet Gave Up Figure Painting," *Art Bulletin* 76 (Dec. 1994): 613–29.

43. One of Bazille's last paintings is his strangely unfinished *Nude Boy on the Grass*. Champa, *Studies*, p. 11, argues that Bazille's image is painted over a rejected first draft for Monet's *Women in the Garden*—a draft still visible in the lower part of this canvas. One might argue that Bazille's painting undertakes literally to erase Monet but, for whatever reason, stops just short of that erasure.

Chronology

Compiled by Phaedra Siebert

1840 November 14: Claude Oscar Monet is born in Paris.

1841 December 6: Jean Frédéric Bazille is born in Montpellier.

1845 Monet's family moves near Le Havre.

1857 Painter Eugène Boudin persuades Monet to join him in painting out-of-doors.

1859 May: Monet goes to Paris to see the Salon and stays to study painting.

1860 Monet enrolls at the *Académie Suisse,* a school that provides models but not instruction. Camille Pissarro is also studying there.

1861 Spring: Monet paints *Corner of a Studio* (fig. 10). By way of the lottery, he is selected for military service and in June joins the *Chasseurs d'Afrique* in Algeria.

1862 Summer–Autumn: Monet falls ill and takes a convalescence leave in Le Havre, where he meets Dutch seascape painter Johan-Barthold Jongkind.

 November: After Monet's recovery, his aunt Sophie Lecadre pays for him to be released from the rest of his military obligation, and he returns to Paris. Bazille moves to Paris, where he enters the École de Médecin and also enrolls in the studio of the Swiss painter Charles Gleyre, who was a leading exponent of the Neo-Grec style and instructed several future Impressionists.

1863 Early Spring: Monet enters Gleyre's studio.

 April: Edouard Manet's *Luncheon on the Grass* (fig. 19) is rejected by the annual Salon. It is instead shown at the *Salon des Refusés.* Monet and Bazille travel together to Chailly-en-Brière, near Fontainebleau, with Auguste Renoir and Alfred Sisley to paint out-of-doors. Bazille returns to Paris after the Easter holiday, but Monet remains until May.

 Summer: Monet visits his family in Le Havre and Sainte-Adresse when Gleyre closes his studio for the annual summer holiday. He returns to Paris and to the studio in the fall. Bazille visits his family in Montpellier from June to October.

 October: Bazille reports to his family that he is painting more than ever and that he would like to rent a studio space. He promises that his medical studies will not suffer.

1864 January: Bazille rents a studio space at 115, rue de Vaugirard with Louis-Emile Villa, a friend from Gleyre's studio.

 March: Bazille fails his medical exam.

April: Monet returns to Chailly for the Easter holiday.

June–July: Bazille and Monet travel via steamboat on the Seine to visit Monet's family in Sainte-Adresse. They stay in Honfleur and work at the farm at Saint-Siméon. Before his departure in autumn, Monet paints *Seaside at Sainte-Adresse* (cat. 2), *The Headland of the Hève, Sainte-Adresse* (cat. 4), and probably also *Beach at Honfleur* (cat. 3). Bazille returns to Paris alone. He receives permission from his father not to continue medical school and dedicates himself to painting.

August–November: Bazille visits his family in Montpellier.

October: Monet's family suspends financial support. He sends three studies to Bazille in Montpellier to sell to collectors there.

December: Back in Paris, Bazille and Monet sign a lease for a studio at 6, rue de Furstenberg, in the same building as Eugène Delacroix's former studio. Because Monet's studies did not sell in Montpellier, Bazille asks his father to forward them to Paris.

1865 January–March: Bazille paints *Studio in the rue de Furstenberg* (cat. 7).

April: Monet goes to Chailly to begin work on a major painting called *Luncheon on the Grass,* which he never completes.

May: Monet's *Headland of the Hève at Low Tide* (cat. 5) is accepted to the Salon. Monet returns to Paris briefly for the opening of the Salon, where his painting is favorably received. Manet's *Olympia* (fig. 33) creates a sensation at the Salon. Bazille briefly visits Monet at Chailly. Back in Paris, Bazille works on *The Beach at Sainte-Adresse* (cat. 1) and *Saint-Sauveur* (fig. 8) for his uncle's home in Montpellier.

Summer: During his time in Chailly, Monet produces, in addition to several landscape sketches for *Luncheon on the Grass, The Bodmer Oak* (cat. 11) and *The Strollers* (cat. 9).

August: Bazille completes *The Beach at Sainte-Adresse* and *Saint-Sauveur* for his uncle and rejoins Monet at Chailly, where he paints *Village Street (Chailly)* (cat. 13) and *Landscape at Chailly* (cat. 12). Bazille also records Monet's convalescence from a leg injury in *The Improvised Field Hospital* (fig. 16).

September–October: Bazille visits his family in Montpellier.

October: Monet and Bazille return to Paris. Monet begins the full-scale version of *Luncheon on the Grass.*

1866 January–March: Monet and Bazille leave their studio in the rue de Furstenberg. Bazille moves into a studio in the rue Godot-de-Mauroy, and Monet moves to the rue Pigalle. Aware that he will be unable to complete his *Luncheon on the Grass* in time, Monet begins *Camille: Woman in a Green Dress* for the Salon. Bazille submits two paintings to the Salon.

May: Bazille's *Still Life with Fish* and Monet's *Camille: Woman in a Green Dress* and *The Chailly Road* are shown at the Salon and receive positive attention from the press. Monet sells several paintings and meets Manet.

Summer: Monet and his mistress, Camille Doncieux, stay in Sèvres, where he works on *Women in the Garden* (fig. 41).

July: Bazille moves into a studio at 20, rue Visconti. Renoir moves in later and shares the rent.

August: Monet and Doncieux move to Honfleur. Bazille begins work on *Terrace at Méric* at his family's home near Montpellier.

November: Bazille returns to Paris.

1867 February–May: Monet joins Renoir and Bazille in their rue Visconti studio.

March: *Terrace at Méric* and *Women in the Garden* are rejected by the Salon. Bazille sends a petition to the Superintendent of Fine Arts—signed by Monet, Renoir, Sisley, Pissarro, and others—requesting an exhibition of refused works.

May: Bazille buys Monet's *Women in the Garden* and paints *Studio in the rue Visconti* (cat. 14). He leaves for Montpellier and takes *Women in the Garden* with him. From his family home, Bazille takes a short trip to Aigues-Mortes, where he paints *The Queen's Gate at Aigues-Mortes* (cat. 16).

June: In order to save money, Monet goes to live with his aunt in Sainte-Adresse, leaving Doncieux, who is pregnant, in Paris. During his summer stay, he paints *Beach at Sainte-Adresse* (fig. 26). Bazille begins *Family Gathering* (fig. 47) that summer at Méric.

July: Monet asks Bazille for advance payments for *Women in the Garden* so that he can send money to Doncieux in Paris. A doctor advises Monet to stop painting out-of-doors because of vision problems.

August 8: Monet and Doncieux's son Jean is born.

October–November: Bazille travels to Bordeaux to visit his friend Edmond Maître and then returns to Paris.

1868 January–February: Bazille and Renoir move their studio to a space in the rue La Condamine. Bazille completes *Family Gathering*.

April: Bazille is named godfather to Jean Monet.

Spring: Monet, Doncieux, and Jean settle near Bennecourt. Monet's *Ships Leaving the Wharves of Le Havre* and Bazille's *Family Gathering* are accepted to the Salon. Monet's painting is seized by creditors when the Salon closes.

May–November: Bazille works in Montpellier and at Méric. He paints *Fisherman Casting a Net* (fig. 32) and *View of the Village* (cat. 20).

June: Monet and his family are forced to leave the inn where they are staying in Bennecourt. In a letter to Bazille, Monet suggests that he has attempted suicide.

July: Monet shows five paintings in the town of Le Havre. As a result, he meets a new patron, Louis-Joachim Gaudibert, who helps to alleviate some of Monet's financial woes.

August: Monet moves with his family to a hotel at Fécamp. They soon rent a small furnished house there.

September–October: Monet travels to Le Havre and Montivilliers to paint a portrait of Gaudibert's wife. Monet moves his family to Etretat in October.

November: Bazille returns to Paris.

December: Monet, having returned to Le Havre, asks Bazille to send him several canvases, both to sell and to paint over, as he is unable to afford new ones.

1869 January: Gaudibert buys back several of Monet's paintings that had been seized by creditors.

February: Bazille receives praise for *View of the Village* and *Fisherman Casting a Net* from his peers.

March: Monet returns to Paris and uses Bazille's studio to finish his entries to the Salon.

May: Monet's works are rejected by the Salon. Bazille shows *View of the Village* at the Salon, and it receives positive criticism from Puvis de Chavannes and others. Bazille travels to Méric to work on *Summer Scene* (fig. 36).

June: Monet, having settled in Saint-Michel near Bougival, paints *The Seine at Bougival in the Evening* (cat. 17) and begins work on scenes of the bathing resort La Grenouillère for the following year's Salon.

August–September: Monet, in dire financial straits, asks Bazille for help.

1870 January: Bazille paints *Studio in the rue La Condamine* (fig. 31). Manet paints Bazille into the picture.

March: Monet's *Luncheon (Interior)* (fig. 44) is rejected by the Salon. François Daubigny and Camille Corot resign from the jury in protest.

April: Bazille moves to the rue des Beaux-Arts.

May: Bazille shows *Summer Scene* at the Salon.

June: Monet and Doncieux marry. Courbet acts as a witness. The couple spend the summer in Trouville, where Monet paints beach scenes.

July: Monet's aunt, Sophie Lecadre, dies. France declares war against Prussia.

August: Bazille enlists; Renoir is drafted.

September: Manet and Degas volunteer for the National Guard.

September–early October: Monet and his family move to London to escape creditors. There he meets the art dealer Paul Durand-Ruel.

November 28: Bazille is killed in fighting at Beaune-la-Rolande, near Orléans.

Selected Bibliography

Bailey, Colin B. *Renoir's Portraits: Impressions of an Age.* New Haven: Yale University Press; Ottawa: National Gallery of Canada, 1997.

Barral, Guy. "Bazille et Montpellier." In *Frédéric Bazille, traces et lieux de la création.* Montpellier: Musée Fabre, 1992.

Baticle, Jeannine, and Pierre Georgel. *L'Atelier: technique de la peinture.* Paris: Editions des Musées Nationaux, 1976.

Boime, Albert. "The Instruction of Charles Gleyre and the Evolution of Painting in the Nineteenth Century." In *Charles Gleyre ou les illusions perdues.* Zurich: Schweizerisches Institut für Kunstwissenschaft, 1974.

Bomford, David, Jo Kirby, John Leighton, and Ashok Roy. *Art in the Making: Impressionism.* New Haven: Yale University Press; London: National Gallery, 1990.

Buren, Daniel. "The Function of the Studio." *October* 10 (fall 1979): 51–58.

Carrier, David. *High Art: Charles Baudelaire and the Origins of Modernist Painting.* University Park: Pennsylvania State University Press, 1996.

Cass, David B. *In the Studio: The Making of Art in Nineteenth-Century France.* Williamstown, Mass.: Sterling and Francine Clark Art Institute, 1981.

Castagnary, Jules Antoine. "Salon of 1857." In *Salons.* 2 vols. Paris: Charpentier, 1892.

Catlin, S. L. "Institute Receives Gift of Early Landscape by Claude Monet." *The Minneapolis Institute of Arts Bulletin* 43 (6 February 1954): 10–14.

Champa, Kermit Swiler. *Studies in Early Impressionism.* New Haven: Yale University Press, 1973.

————. "Frédéric Bazille, the 1978 Retrospective Exhibition." *Arts Magazine* 52 (June 1978): 108–10.

————. "Concert Music: The Master Model for Radical Painting in France." Paper presented at the 16th International Congress of the International Musicological Society, London, August 1997.

Clark, T. J. *The Painting of Modern Life: Paris in the Art of Manet and His Followers.* New York: Alfred A. Knopf, 1985.

Coles, William A. *Alfred Stevens.* Ann Arbor: University of Michigan Museum of Art, 1977.

Condon, Patricia, et al. *In Pursuit of Perfection: The Art of J.-A.-D. Ingres.* Bloomington: Indiana University Press, 1983.

Courbet, Gustave. *Letters of Gustave Courbet.* Ed. and trans. Petra ten-Doesschate Chu. Chicago: University of Chicago Press, 1992.

Daulte, François. *Frédéric Bazille et son temps.* Geneva: Pierre Cailler, 1952.

————. *Frédéric Bazille et les débuts de l'impressionisme: Catalogue raisonné de l'oeuvre peint.* Paris: Bibliothèque des Arts, 1992.

Dean, Carolyn. *Sexuality and Modern Western Culture.* New York: Twayne Publishers, 1996.

Derrida, Jacques. *The Truth in Painting.* Chicago: University of Chicago Press, 1987.

Du Camp, Maxime. "Le Salon de 1866." In *Les Beaux-Arts à l'exposition universelle et aux salons de 1863, 1864, 1865, 1866, & 1867.* Paris: Jules Renouard, 1867.

Eyerman, Charlotte N. "The Composition of Femininity: The Significance of the 'Woman at the Piano' Motif in Nineteenth-Century French Culture from Daumier to Renoir." Ph.D. diss., University of California at Berkeley, 1997.

Fairbrother, Trevor. *John Singer Sargent.* New York: Abrams, 1994.

Faunce, Sarah, and Linda Nochlin, eds. *Courbet Reconsidered.* Brooklyn: Brooklyn Museum of Art, 1988.

Foucault, Michel. *The History of Sexuality.* Trans. Robert Hurley. 2 vols. New York: Pantheon Books, 1978.

Fried, Michael. *Absorption and Theatricality: Painting and Beholder in the Age of Diderot.* Berkeley and Los Angeles: University of California Press, 1980.

————. *Realism, Writing, Disfiguration: On Thomas Eakins and Stephen Crane.* Chicago: University of Chicago Press, 1987.

————. *Courbet's Realism.* Chicago: University of Chicago Press, 1990.

————. *Manet's Modernism, or The Face of Painting in the 1860s.* Chicago: University of Chicago Press, 1996.

Galassi, Peter. *Corot in Italy: Open-Air Painting and the Classical-Landscape Tradition.* New Haven: Yale University Press, 1991.

Garb, Tamar. "Gender and Representation." In *Modernity and Modernism: French Painting in the Nineteenth Century,* by Francis Frascina et al. New Haven: Yale University Press, 1993.

Geffroy, Gustave. *Monet, sa vie, son oeuvre.* 1924. Reprint, Paris: Macula, 1980.

Georgel, Pierre, and Anne-Marie Lecoq. *La peinture dans la peinture.* Dijon: Musée des Beaux-Arts, 1983.

Hauptman, William. "Delaroche's and Gleyre's Teaching Ateliers and Their Group Portraits." In *Studies in the History of Art.* Vol. 18. Hanover, New Hampshire: University Press of New England, 1985.

Herbert, Robert L. "Method and Meaning in Monet." *Art in America* 67, no. 7 (Sept. 1979): 90–108.

————. *Monet on the Normandy Coast: Tourism and Painting, 1867–1886.* New Haven: Yale University Press, 1994.

Isaacson, Joel. *Monet: Le déjeuner sur l'herbe.* London: Penguin Press, 1972.

————. *Claude Monet: Observation and Reflection.* Oxford: Phaidon; New York: Dutton, 1978.

————. "Observation and Experiment in the Early Work of Monet." In *Aspects of Monet.* Ed. John Rewald and Frances Weitzenhoffer. New York: Abrams, 1984.

Johnson, Lee. *The Paintings of Eugène Delacroix: A Critical Catalogue.* 4 vols. Oxford: Clarendon, 1981–86.

Johnston, William R. *The Nineteenth-Century Paintings in the Walters Art Gallery.* Baltimore: Walters Art Gallery, 1982.

Jourdan, Aleth, et al. *Frédéric Bazille, Prophet of Impressionism.* Brooklyn: Brooklyn Museum of Art; Montpellier: Musée Fabre, 1992.

Lebensztejn, Jean-Claude. "Starting Out from the Frame (Vignettes)." In *Deconstruction and the Visual Arts: Art, Media, Architecture.* Ed. Peter Brunette and David Wills. Cambridge, England: Cambridge University Press, 1994.

Lethève, Jacques. *Daily Life of French Artists in the Nineteenth Century.* London: Allen and Unwin, 1972.

Levine, Steven Z. *Monet, Narcissus, and Self-Reflection: The Modernist Myth of the Self.* Chicago: University of Chicago Press, 1994.

Mantz, Paul. "Salon de 1865." *Gazette des Beaux-Arts* 18 (Jan.–June 1865): 489–523; 19 (July–Dec. 1865): 5–42.

Marandel, J. Patrice, ed. *Frédéric Bazille and Early Impressionism.* Chicago: Art Institute of Chicago, 1978.

Marin, Louis. "The Frame of Representation and Some of Its Figures." In *The Rhetoric of the Frame: Essays on the Boundaries of the Artwork.* Ed. Paul Duro. Cambridge, England: Cambridge University Press, 1996.

Mendgen, Eva, ed. *In Perfect Harmony: Picture + Frame, 1850–1920.* Amsterdam: Van Gogh Museum; Vienna: Kunstforum Wien, 1995.

Milliet, Paul. *Une famille de républicains fouriéristes.* 2 vols. Paris: Giard and Brière, 1915–16.

Mitchell, Paul, and Lynn Roberts. *A History of European Picture Frames.* London: Merrell Holberton, 1996.

Montégut, Emile. "Charles Gleyre." *Revue des deux mondes* (15 September 1878): 395–426.

Moriarty, Michael. "Structures of Cultural Production in Nineteenth-Century France." In *Artistic Relations: Literature and the Visual Arts in Nineteenth-Century France.* Ed. Peter Collier and Robert Lethbridge. New Haven: Yale University Press, 1994.

Morisot, Berthe. *Berthe Morisot—The Correspondence.* Ed. Denis Rouart. London: Moyer Bell Limited, 1987.

Peppiatt, Michael, and Alice Bellony-Rewald. *Imagination's Chamber: Artists and Their Studios.* Boston: New York Graphic Society, 1982.

Pitman, Dianne W. *Bazille: Purity, Pose, and Painting in the 1860s.* University Park: Pennsylvania State University Press, 1998.

Poulain, Gaston. *Bazille et ses amis.* Paris: Renaissance du Livre, 1932.

Privat, Gonzague. *Place aux jeunes! Causeries critiques sur le salon de 1865.* Paris: F. Cournol, 1865.

Rewald, John. *The History of Impressionism.* Rev. ed. New York: Museum of Modern Art, 1961.

Roos, Jane Mayo. *Early Impressionism and the French State 1866–1874.* New York and Cambridge, England: Cambridge University Press, 1996.

Roskill, Mark. "Early Impressionism and the Fashion Print." *Burlington Magazine* 112 (1970): 391–95.

Sarraute, Gabriel. "Catalogue de l'oeuvre de Frédéric Bazille." Thesis, Ecole du Louvre, Paris, 1948.

Schapiro, Meyer. *Impressionism: Reflections and Perceptions.* New York: George Braziller, 1997.

Schulman, Michel. *Frédéric Bazille, 1841–1870: Catalogue raisonné.* Paris: Éditions de l'Amateur, 1995.

Shiff, Richard. *Cézanne and the End of Impressionism: A Study of the Theory, Technique, and Critical Evaluation of Modern Art*. Chicago: University of Chicago Press, 1984.

Steinberg, Leo. "Introduction: The Glorious Company." In *Art About Art*. Ed. Jean Lipman and Richard Marshall. New York: Dutton, 1978.

Stuckey, Charles. *Claude Monet, 1840–1926*. Chicago: Art Institute of Chicago; New York: Thames and Hudson, 1995.

Taboureux, Emile. "Claude Monet." *La vie moderne* (12 June 1880). Reprinted in *Monet: A Retrospective*. Ed. Charles F. Stuckey. New York: Levin Associates, 1985.

Tinterow, Gary, and Henri Loyrette. *Origins of Impressionism*. New York: Metropolitan Museum of Art, 1994.

Tucker, Paul Hayes. *Claude Monet: Life and Art*. New Haven: Yale University Press, 1995.

Wagner, Anne M. "Why Monet Gave Up Figure Painting." *Art Bulletin* 76 (Dec. 1994): 613–29.

Wildenstein, Daniel. *Monet*. 4 vols. Lausanne and Paris: Bibliothèque des Arts, 1974–85. Rev. ed. Cologne: Taschen Verlag, 1996.

Zola, Émile. *L'oeuvre*. Paris: G. Charpentier, 1886.

Checklist of the Exhibition

CATALOGUES RAISONNÉS:

W. = Wildenstein, Daniel. *Monet.* 4 vols. Lausanne and Paris: Bibliothèque des Arts, 1974–85; Rev. ed. Cologne: Taschen Verlag, 1996.

D. = Daulte, François. *Frédéric Bazille et les débuts de l'impressionisme: Catalogue raisonné de l'oeuvre peint.* Paris: Bibliothèque des Arts, 1992.

S. = Schulman, Michel. *Frédéric Bazille, 1841–1870: Catalogue raisonné.* Paris: Éditions de l'Amateur, 1995.

1.

Frédéric Bazille (1841–1870)
The Beach at Sainte-Adresse, 1865
Oil on canvas
23 × 55⅛ inches (58.4 × 140 cm)
High Museum of Art; Gift of The
Forward Arts Foundation in honor of
Frances Floyd Cocke, 1980.62
D. 17; S. 18

2.

Claude Monet (1840–1926)
Seaside at Sainte-Adresse, 1864
Oil on canvas
15¾ × 28¾ inches (40 × 73 cm)
The Minneapolis Institute of Arts; Gift of
Mr. and Mrs. Theodore Bennett, 53.13
W. 22

3.

Claude Monet
Beach at Honfleur, 1864–65
Oil on canvas
23½ × 32 inches (59.7 × 81.3 cm)
Los Angeles County Museum of Art;
Gift of Mrs. Reese Hale Taylor, 64.4
W. 41

4.

Claude Monet
The Headland of the Hève, Sainte-Adresse, 1864
Oil on canvas
16⅛ × 28¾ inches (41 × 73 cm)
National Gallery, London, NG6565
W. 39

5.

Claude Monet
The Headland of the Hève at Low Tide, 1865
Oil on canvas
35½ × 59¼ inches (90 × 150 cm)
Kimbell Art Museum, Fort Worth,
Texas, AP 1968.07
W. 52

6.

Gilbert de Sévérac (1834–1897)
Portrait of Monet, ca. 1860–61
Oil on canvas
15¾ × 12½ inches (40 × 32 cm)
Musée Marmottan, Paris, 5065

7.

Frédéric Bazille
Studio in the rue de Furstenberg, 1865
Oil on canvas
31½ × 25⅝ inches (80 × 65 cm)
Musée Fabre, Montpellier, France, 85.5.3
D. 18; S. 21

8.

Marc-Gabriel-Charles Gleyre (1825–1905)
The Bath, 1868
Oil on canvas
35½ × 25 inches (90.2 × 63.5 cm)
The Chrysler Museum of Art,
Norfolk, Virginia; Gift of Walter P.
Chrysler, Jr., 71.2069

9.

Claude Monet
The Strollers, 1865
Oil on canvas
36⅝ × 27⅛ inches (93 × 68.9 cm)
National Gallery of Art, Washington, D.C.;
Ailsa Mellon Bruce Collection, 1970.17.41
W. 61

10.

Théodore Rousseau (1812–1867)
Sunset over the Plain of Barbizon, ca. 1860
Oil on canvas
16¼ × 25¾ inches (38.7 × 65.4 cm)
Collection of Richard B. Kellam,
Virginia Beach, Virginia

11.

Claude Monet

The Bodmer Oak, Fontainebleau Forest,
the Chailly Road, 1865

Oil on canvas

37¾ × 50¾ inches (96.2 × 129.2 cm)

The Metropolitan Museum of Art, New
York; Gift of Sam Salz and Bequest of Julia
W. Emmons, by exchange, 1964, 64.210

W. 60

12.

Frédéric Bazille

Landscape at Chailly, 1865

Oil on canvas

32 × 40 inches (81.3 × 101.6 cm)

The Art Institute of Chicago;
Charles H. and Mary F. S. Worcester
Collection, 1973.64

D. 12; S.14

13.

Frédéric Bazille

Village Street (Chailly), 1865

Oil on canvas

12¾ × 9½ inches (32.4 × 24.1 cm)

Private Collection

D. 13; S. 16

14.

Frédéric Bazille

Studio in the rue Visconti, 1867

Oil on canvas

25⅛ × 19¼ inches (64 × 49 cm)

Virginia Museum of Fine Arts,
Richmond; Collection of
Mr. and Mrs. Paul W. Mellon, 83.4

D. 23; S. 27

15.

Frédéric Bazille

The Sea Gull, 1864

Oil on canvas

18⅛ × 15 inches (46 × 38 cm)

Private Collection

D. 8; S. 12

16.

Frédéric Bazille

The Queen's Gate at Aigues-Mortes, 1867

Oil on canvas

31¾ × 39¼ inches (79.4 × 99.7 cm)

The Metropolitan Museum of Art, New
York; Purchase, Gift of Raymonde Paul,
in memory of her brother, C. Michael Paul,
by exchange, 1988, 1988.21

D. 26; S. 32

17.

Claude Monet

The Seine at Bougival in the Evening, 1869

Oil on canvas

23⅝ × 29 inches (60 × 73.5 cm)

Smith College Museum of Art,
Northampton, Massachusetts;
Purchase 1946

W. 151

18.

Frédéric Bazille

Self-Portrait, 1867–68

Oil on canvas

21½ × 18¼ inches (54.6 × 46.4 cm)

The Minneapolis Institute of Arts;
The John R. Van Derlip Fund, 62.39

D. 37; S. 39

19.

Gustave Courbet (1819–1877)

Beach Scene with a Boat, ca. 1869

Oil on canvas

18¾ × 21¼ inches (47.6 × 54 cm)

Private Collection

20.

Frédéric Bazille

View of the Village, 1868

Oil on canvas

51⅛ × 35 inches (130 × 89 cm)

Musée Fabre, Montpellier, France, 898.5.1

D. 39; S. 46

Photograph Credits